# · ELIZABETH ·
# BLACKADDER

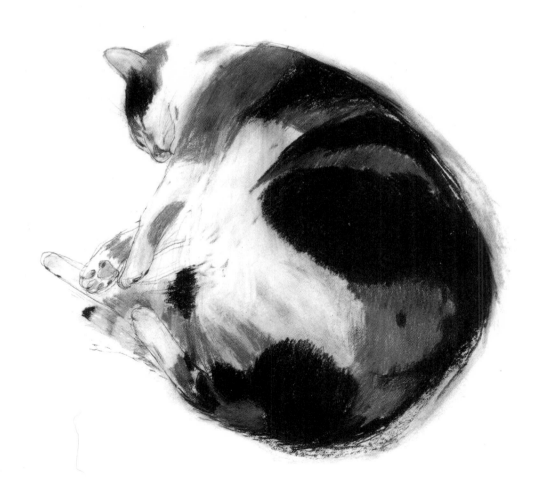

# ELIZABETH

## JUDITH BUMPUS

# BLACKADDER

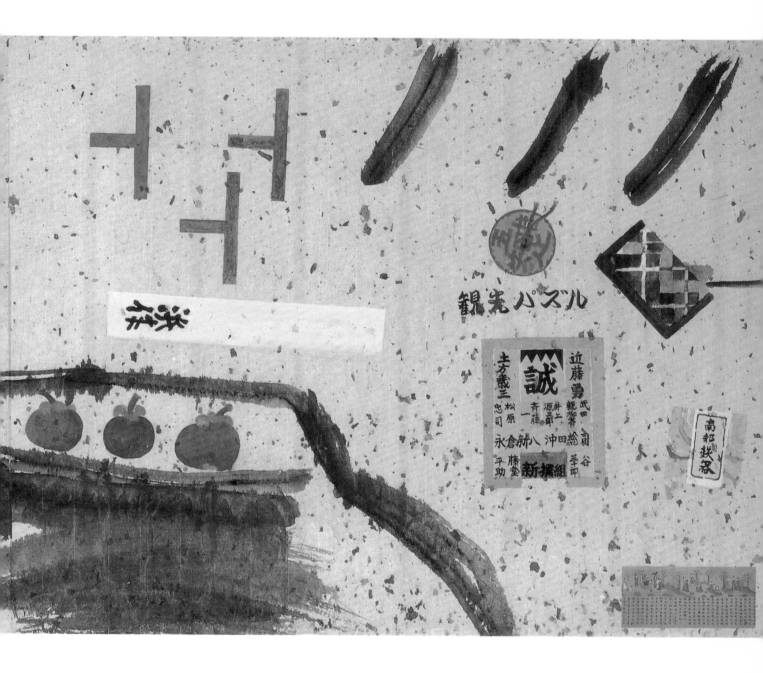

PHAIDON · OXFORD

# To Bernard

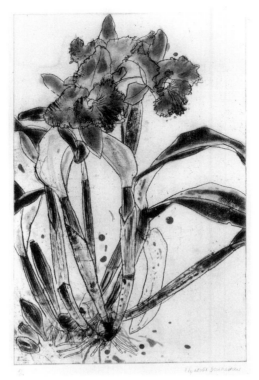

(above)   *Orchid*. 1986. Etching and aquatint, 50.8 × 33 cm (20 × 13 in). Collection of the artist

(title page)   *Still Life, Kyoto*. 1985. Watercolour, 82.5 × 158.7 cm (32½ × '62½ in). Private collection

(frontispiece)   *Tortoiseshell Cat Asleep*. 1987. Watercolour, 59.7 × 41.9 cm (23½ × 16½ in). Collection of the artist

Phaidon Press Limited, Littlegate House, St. Ebbe's Street, Oxford OX1 1SQ

First published 1988
© 1988 Phaidon Press Limited

British Library Cataloguing in Publication Data

Bumpus, Judith
   Elizabeth Blackadder.
   1. Scottish paintings. Blackadder, Elizabeth
   I. Title
   759.2

ISBN 0–7148–2520–4

Printed in Great Britain by Ebenezer Baylis & Son Ltd, Worcester

The publishers wish to thank Elizabeth Blackadder for her assistance in preparing this volume for publication. They are also indebted to Gillian Raffles of the Mercury Gallery. They acknowledge a subsidy for the book from the Scottish Arts Council and extend thanks to the Russell Trust, Markinch, Fife, which has generously provided the paper, Mellotex Smooth Super White, 135 g/m$^2$, from Tullis Russell the Papermakers.

# CONTENTS

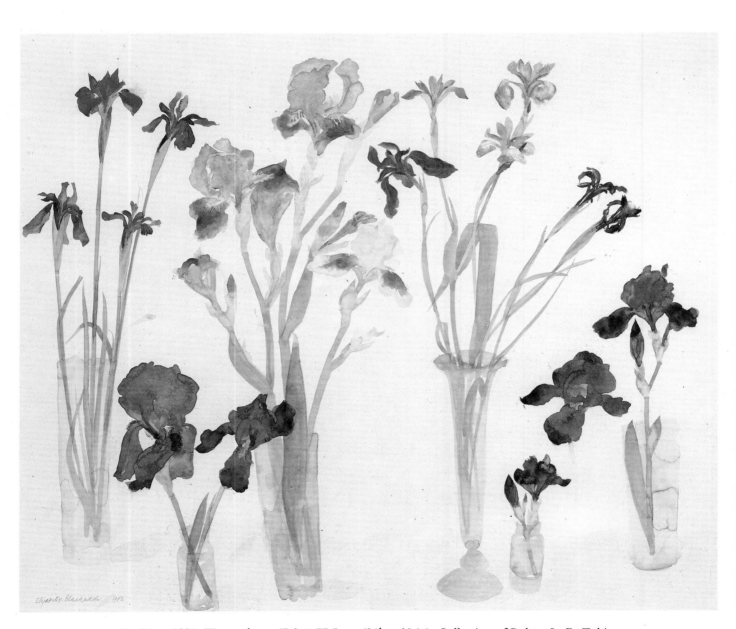

1. *Irises*. 1984. Watercolour, 67.3 × 77.5 cm (26½ × 30 in). Collection of Robert L. B. Tobin

# INTRODUCTION

This short book cannot offer a definitive study of Elizabeth Blackadder's work, yet I hope that it contributes to the understanding and appreciation of an artist who has long been admired by other artists and who is increasingly popular with the general public. If the question can still be asked: Why haven't we heard more about Elizabeth Blackadder?, the answer lies as much in the nature of the artist as in the character of her work. Her subjects are intimate and domestic and to some observers the results may appear narrow and provincial, but they possess qualities every bit as valuable as painting that is more declamatory and sensational. Elizabeth Blackadder has courted neither fashion nor limelight, shunning what some would regard as the conventional channels of success. She has chosen to remain in Scotland and has been content, in the unceasing pursuance of her work, to allow her audience to catch up with and discover her in its own time.

In researching this book, I have benefited from conversations with Elizabeth Blackadder over the past six years and all the quotations, unless otherwise stated, are drawn from our discussions. I have been greatly assisted by the artist herself and by John Houston, her husband. They not only offered me their warm hospitality in Edinburgh, but gave generous help in selecting the illustrations and have approved the text for publication. I am deeply grateful both to them and to Gillian Raffles, Director of the Mercury Gallery.

I should also like to thank the many people who have guided me enthusiastically round their collections and shared their knowledge with me. Among those with whom I have enjoyed fruitful conversation and correspondence I should like, in particular, to mention: the late Violet Blackadder, Marion Blackadder, Thomas and Pat Blackadder, Dr Eric Blackadder, Jean Blackadder, Errol Bedford, John Busby, Dr Brinsley Burbidge, Marjorie Cairns, Allan Carr, Sir Hugh Casson, Betty Clark, Derek Clarke, Stewart Cordiner, Barbara Dawson, Joanna Drew, Robert Erskine, Alex Howson, Edward and Valerie Gage, Ursula Gill, Maureen Hodge, Monica Hunter, Isobel Johnstone, Stanley Jones, Eileen Lawrence, Mabel Lyon, Peter Lyon, Theresa Margaret C.H.N., Margaret Mathieson, David Michie, Rosemary Miles, Jim Mooney, David C. Mackenzie, James Mowat, David McClure, Margaret E. MacNair, Mary M. Nixon, Professor Patrick Nuttgens, Sir Robin Philipson, William Packer, Andrew Purchase, Hamish Reid, Leonard Rosoman, Effie Ross, the late Professor Giles Robertson, John M. Sanderson, Mrs Margaret Scott, Joanne Soroka, Tamara Talbot Rice, Ailsa Tanner, Mary Taubman, Frances Walker, Dorothy Watts, Dorothy Williamson and Beatrice Wober.

I am indebted also to Frank Whitford for kindly reading and commenting on the text and, finally, to my family for support, encouragement and innumerable cups of coffee.

Judith Bumpus, London, March 1988

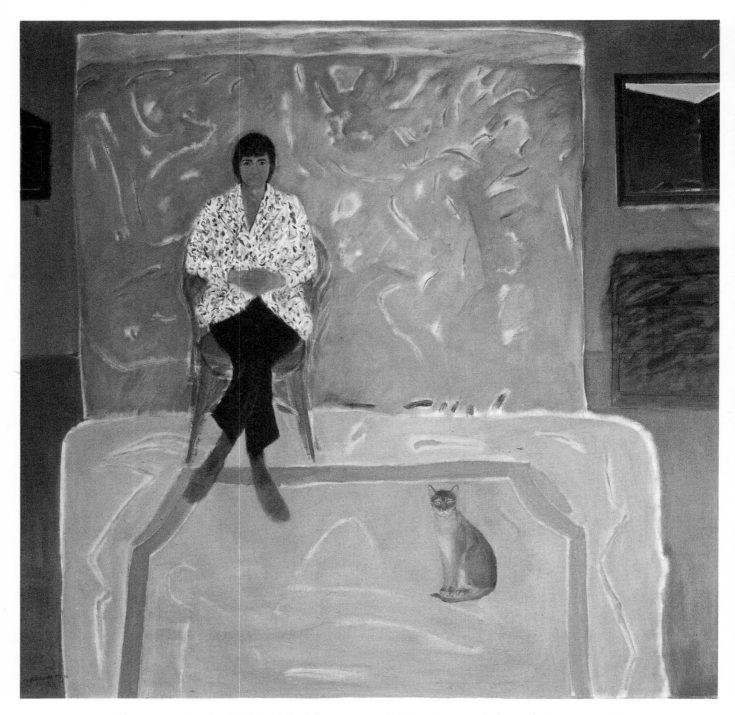

2. *Self-portrait, Embroidered Jacket*. 1973. Oil on canvas, 120.7 × 120.7 cm (47½ × 47½ in). Private collection

# ELIZABETH BLACKADDER

A voracious reader of other people's words, Elizabeth Blackadder uses them sparingly. She rarely volunteers information about herself and, in conversation or in writing about her work, she tends to be matter-of-fact. Her only published statement, written in 1979 for the directory of *Contemporary British Artists*, includes the following account:

> I work in oil and watercolour with no particular preference.
>
> My work is all based on some point of reference although it may move away greatly from the starting-off point before it is finished. I am less interested in the actual likeness of things than in setting up relationships between the objects and between them and the background.
>
> The work falls into two main areas, landscape and still life—occasionally figures. Still-life paintings are based on a very large collection of all kinds of objects—toys, boxes, ribbons, fans, pieces of paper, scraps of cloth, flowers, stones—anything at all that attracts my attention.

Recently she has added that 'since 1979 I have continued to draw landscape and the figure, but my painting has been mainly in watercolour—flower studies and large still lifes on Japanese paper.'

Elizabeth Blackadder's commonsensical prose confines itself to the essentials of her work: shape, colour and visual relationships. It admits no personal or theoretical indulgence and compares surprisingly with the expansive instincts of her painting. The reason she prefers not to elaborate her references or possible meanings in her work is not, it would seem, a desire to be secretive but to bring the enquirer gently back to what is relevant to her activity as an artist. In attitude such verbal restraint reflects the words of the old Chinese proverb: one showing is worth a hundred sayings.

The reference to Chinese wisdom is not an idle one. The artist's fascination with the Eastern mind through its art and artefacts goes back to her childhood, but her more recent readings in Tao and Zen have surprised her with the number of meeting points between Oriental philosophy and the intuitive springs of creativity.

A silent disposition may make the task of the writer more difficult, but Elizabeth Blackadder's insistence on using her own language forces us to concentrate on the pictorial evidence. She has chosen not to write a preface to this book as she hopes that the paintings speak eloquently enough for themselves. It would seem appropriate, therefore, to introduce the artist and her work with the eight self-portraits she painted between 1951 and 1982.

She worked on the first, a small head and shoulders in oil, during the summer of 1951, at the end of her second year at Edinburgh College of Art (Pl. 4). She was nearly twenty at the time, and

she confronted her own image thoughtfully and candidly in order, as she said, 'to explore problems of form and structure and qualities of light'. A year later she made a small etching, which showed her, still a student, drawing in her room.

Some twenty years passed before Elizabeth returned to self-portraiture in 1972, by which time her pictorial ideas had matured and crystallized. *Interior with Self-portrait* (Pl. 5) focuses on a room in which perspectives and appearances have been transformed by the artist's imagination. She wears a kimono and the painting has a strong Eastern flavour that contrasts strangely with a quieter, more domestic watercolour done the following year, *Self-portrait with Cat* (1973, not illustrated).

The home setting—furniture, rugs, flowers, cats and ornaments—had now taken precedence in her work and she herself adopted an accompanying role in the designs. Sharing Pierre Bonnard's devotion to the primacy of 'the idea', she made details of her own physical appearance subservient to the overall composition. Individual features of her face and figure are still recognizable, but are reduced to their essentials. The inspirational idea for a picture might be a kimono, a spotted blouse and floral skirt or a favourite striped shirt, and each one infuses a painting with a different mood and movement.

Elizabeth's dislike of public performance is implicit in the very appearance she makes on the scene, almost sidling into the picture on occasion, refusing to look in our direction. She gives away nothing of herself, although she evidently takes sophisticated pleasure in unusual fabric and the design of clothes, in the furnishing of her home and in flowers. And she introduces us to her cats. The impression is one of intimate domesticity, but rarely of the comfortable family kind portrayed

3. *Flowers in a Black Jug.* 1953. Oil on canvas, 61 × 40.6 cm (24 × 16 in). Private collection

4. *Self-portrait.* 1951. Oil on canvas, 35.6 × 30.5 cm (14 × 12 in). Private collection

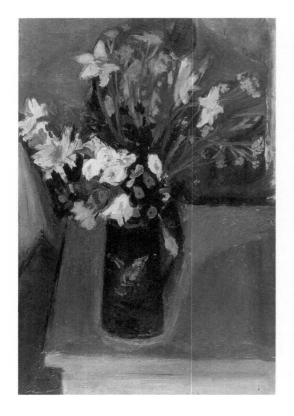
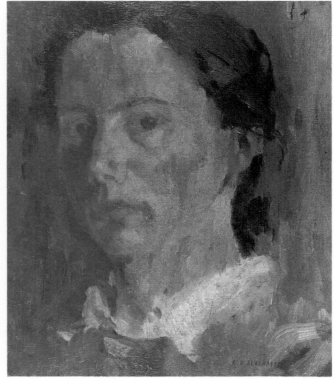

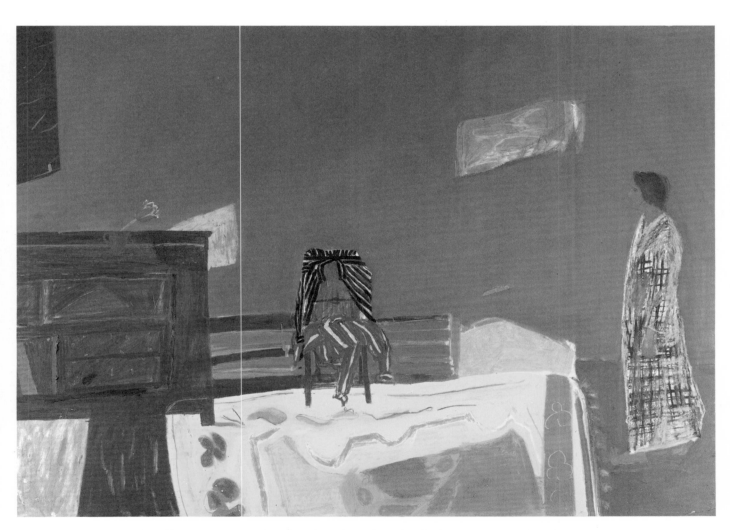

5. *Interior with Self-portrait*. 1972. Oil on board, 95.3 × 127 cm (37½ × 50 in). Nottinghamshire County Council, Education Support Service

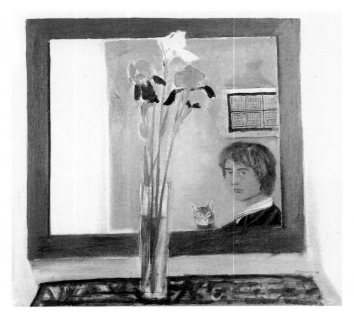 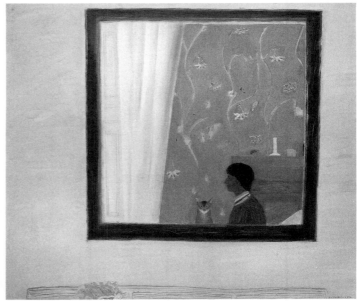

6. *Self-portrait with Irises and Cat*. 1982. Oil on canvas, 50.8 × 50.8 cm (20 × 20 in). Devonshire Collection, Chatsworth

7. *Self-portrait with Cat*. 1976. Oil on canvas, 109.2 × 125.5 cm (43 × 49 in). Royal Scottish Academy, Edinburgh

by the French artists Bonnard and Vuillard, who were important formative influences on her work.

Clearly the significance of Elizabeth Blackadder's self-portraits of the 1970s and 1980s is not the portrait in any traditional Western sense. Compositionally, the inclusion of the human figure is not unlike the presence of the figure striding among worldly possessions on Egyptian tomb paintings and reliefs. Seen in this way, the later self-portraits are an introduction to the private world of her still lifes.

In *Self-portrait, Embroidered Jacket* (Pl. 2), an elaborately embroidered jacket sets off another colourful train of thought. Being full face, the portrait is more descriptive, but the artist's expression remains detached. As in all her work, 'one thing leads to another', and the mirror that opens up perspectives in the corner of this painting now shifts to the centre of the stage and frames, at one more remove, the subject of *Self-portrait with Indian Mirror* (1973) and the 1976 *Self-portrait with Cat* (Pl. 7). The latter was her diploma painting for the Royal Scottish Academy.

In *Self-portrait with Cat* the artist's head and shoulders are seen in profile beside that of her Abyssinian cat, staring out at us, confident and unblinking. It is the cat that is doing the looking, admiring its reflection in a large mirror. The artist is there almost, it seems, by accident, a casual bystander. Elizabeth's delight in chance appearances, whether of her own head or of one of her cats, echoes Bonnard's delight in surprising us with *contre-jour* effects or in catching the sudden, distorting movement of a face. She clearly enjoys the spatial paradoxes contained in the painting as well as the formal problems set up by the mirror and in 1982 she resumes the challenge of this theme in *Self-portrait with Irises and Cat* (Pl. 6). Her Edinburgh home is still the most resonant subject but the picture also registers her increasing interest in painting flowers, especially the irises grown in her garden.

Elizabeth Blackadder has lived and worked in Edinburgh for forty years. She travels frequently in order 'to see for myself other cultures and works by other artists which interest me

and which may influence my own work'. But it is to Edinburgh that she returns to sift and refine these assorted experiences and it is within the Edinburgh tradition of painting that her sensuous and poetic responses can best be appreciated. From a leading member of that tradition, William Gillies, she absorbed the practical philosophy by which he guided his students: always be true to oneself.

Trusting to her instincts, giving form to feelings and perfecting an individual calligraphy have involved Elizabeth in years of work using a narrow range of personal subject-matter: jugs, cats, flowers, puzzles, toys, musical instruments, boxes, ribbons and fans. The fact that she does not consider herself to be a member of any particular 'school' is as much a tribute to the diversity of Scottish painting in the last quarter of the twentieth century as it is to her inventiveness. Extending admiration for the way in which she has been constant to a vision both modest and entirely her own, Carel Weight summarized her achievement in a Foreword to her 1981 retrospective exhibition catalogue with these words: 'Her pictures are completely unpretentious and owe nothing to current fashion. They are an artistic expression of her life and herself.'

# Early Years and Widening Horizons

Elizabeth Violet Blackadder was born on 24 September 1931 in Falkirk, Stirlingshire, a town midway between Edinburgh and Glasgow. Falkirk was proud of its Roman foundations and of the industrial history that had earned it a reputation as the centre of Britain's light castings industry. Blackadders had been associated with the emergence of the town as an industrial centre from the late eighteenth century, when William Blackadder, a millwright from the village of Port Seton in East Lothian, is said to have sought employment with the Carron Company ironworks. In 1851 one of William's enterprising grandchildren, Thomas, Elizabeth's great-grandfather, opened his own engineering firm in Falkirk and succeeding generations were to secure a substantial reputation for the family in the foundry and motor-engineering businesses. Elizabeth's father, also called Thomas, was apprenticed to the Blackadder Brothers' Garrison Foundry and Engine Works just before World War I.

Elizabeth's grandfather, a marine engineer, built a solid sandstone house beside the works and named it Glenmorag, after the sailing ship in which he had served his apprenticeship to the Antipodes. It was here, at 6 Weir Street, that Elizabeth was born and brought up, the second child of Thomas and Violet Isabella Blackadder. Elizabeth's brother, her senior by five years, recalls his sister, dark haired and pink cheeked, as physically and temperamentally taking after their father, who was a reserved and thoughtful man of gentle demeanour and strong determination. He was a mechanical engineer and a fine draughtsman, who 'could turn his hand to anything and make anything'. He was also an amateur photographer and had set up his own darkroom.

From her mother Elizabeth absorbed a high-principled and practical attitude to life, as well as an appreciation of literature and music. Violet Blackadder was the daughter of James Scott, a marine engineer of Grangemouth. She had persisted in training as a domestic science teacher supported only grudgingly by her father. Resolving to spare Elizabeth a similar struggle she made sure that her daugher benefited from the most promising educational opportunities. Elizabeth's

own fixity of purpose may, in some measure, have been shaped by a sense of her mother's expectations.

Elizabeth remembers their house as being 'full of objects', T-squares, set squares and drawing boards, as well as photographs in elaborate frames, books, steel engravings after Landseer, a barrel organ from Italy, china pot-pourri jars, a nineteenth-century Japanese lacquer box, shells, Napoleonic relics and many other mementoes brought back by her grandfather from his trips abroad.

Recollections of childhood are traceable as no more than distant echoes in her mature painting, but the character of the family home and its possessions must have influenced the perceptions of the future artist. The habit of quiet and persistent looking developed in her an unusual fascination with objects and provided a store of associative memories. Indeed, pieces of family furniture together with many of her grandfather's 'souvenirs' are still a treasured part of her own much larger collection today. As a child she was alive to everything going on around her and, although she enjoyed drawing, she was not preoccupied with it to the exclusion of everything else. Nevertheless, a natural aptitude is evident in the eight-year-old's drawing of boats on Holy Loch, where she spent holidays with her maternal grandmother.

Much of her childhood was spent on her own and to this Elizabeth attributes the keen appetite for reading which she developed from the age of eight or nine. Another solitary activity to which she turned a few years later was the compilation of a meticulous collection of local flowers, pressed and labelled with their full Latin names. Her fascination with this hobby was to surface much later in her paintings of plants and flowers. As she grew up the experience of living in a busy industrial environment instilled in her a curiosity about 'the way things work' that continues, although in transmuted form, to distinguish the design of her still lifes and botanical drawings.

Elizabeth was educated at Falkirk High School, where she realized her academic and creative potential, as well as winning admiration for her leadership as an energetic school hockey captain and, in her final year, as an active and unassuming head girl. A.C. MacKenzie was Rector at the time and Elizabeth remembers the enjoyment she derived from his enthusiastic teaching of poetry, particularly Romantic verse. She also remembers the pleasure of dissecting and drawing plants as part of her botanical studies and, in particular, her art classes. Her brother Thomas followed a career in engineering, but it was clear that her own curiosity was mainly imaginative and artistic rather than scientific or mechanical and she spent much of her sixth school year in the art room. The art department was run by James Scott, a charming teacher who recognized his pupil's ability and gave her 'every encouragement'.

Her visual appreciation was undoubtedly stimulated by the amateur archaeologist, William Bulmer, a distant relative, whom Elizabeth visited from early childhood. Bulmer was curator of the Corstopitum Museum in Corbridge and he used to show Elizabeth the Roman remains and artefacts on the site. He also encouraged her fascination with pictures by giving her illustrated catalogues of Royal Academy summer shows.

Elizabeth's early knowledge of modern art was largely of British examples, although she would have seen displays of French Impressionist and post-Impressionist painting in the Glasgow Art Gallery when she visited it with her art teacher and, later, when she took a holiday job in the gallery. It was here that she formed an admiration for artists of the Glasgow School such as Joseph Crawhall and the Scottish Colourists.

A pressing question was where her interest in art would lead her. Thomas Ferguson, a professor at Glasgow University who was a close family friend, advised that if she were considering museum work or art teaching as a career, she would do well to study for the new Fine

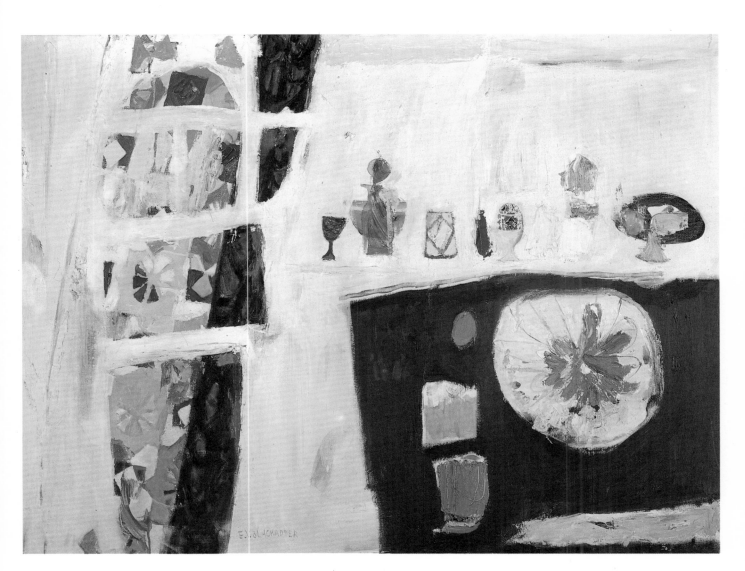

8. *White Still Life, Easter* (Guthrie Award). 1962. Oil on canvas, 86.4 × 111.8 cm (34 × 44 in). Private collection

Art degree at Edinburgh. This degree had been approved by the University Senate in 1947, largely at the combined instigation of the educational pioneer Robert Lyon, Principal of the College of Art, and of the archaeologist and Byzantine scholar, David Talbot Rice, Herbert Read's successor to the Watson Gordon Chair of Fine Art in the university. For painting students the five-year course promised its successful graduates a joint degree from two entirely separate institutions: a Diploma of Art from the college and an M.A. Honours degree in art history from the university, the first qualification of its kind in Britain.

When Elizabeth Blackadder arrived in Edinburgh in September 1949 to start the Fine Art course she found the prospect exhilarating. It might have been daunting, had she known exactly what was in store. The demands both physical and mental were exceptional, and students frequently complained, as they still do, about the difficulty of reconciling the interests of the studio with those of the university. In common with other national art schools in Britain, teaching at the college was traditionally academic. Stress was laid on training the eye through the disciplines of drawing and painting and such was the influence of this teaching that the element of drawing remains a persuasive feature of Elizabeth Blackadder's work today.

One of the earliest and most enduring influences on her work was William Gillies, an inspired teacher. He was a man of few words, but his brief comments on a drawing or painting, made with good humour, were always encouragingly to the point. Under his leadership, the School of Drawing and Painting constantly encouraged the serious student to develop an individual voice. The staff were practising artists and education was conducted as much by example as by precept and demonstration. Gillies himself was a prolific and inventive painter of landscape and still life in oil and watercolour. Immensely energetic, he showed just what a gifted and hard-working artist could achieve. Elizabeth could see his work and that of her other teachers—Penelope Beaton, Robert Henderson Blyth, William MacTaggart and Robin Philipson—at the annual exhibitions of the Scottish Academy, the Watercolour Society, the Society of Scottish Artists and at Aitken Dott and Sons' The Scottish Gallery, one of the few Edinburgh galleries that dealt in contemporary art. To a young and impressionable girl from a provincial community, 'the idea that someone could actually have a life as a painter was new and very important.'

Her encounter with classical and Byzantine art, through David Talbot Rice's lectures, was also of seminal importance, and Elizabeth continues to pay tribute to his influence in opening up to her the world of Byzantine, Islamic and Persian art. The experience certainly inspired her later travels to Greece, Turkey and Italy. While she admired the structure and spatial concepts of Byzantine buildings, her attention was mostly engaged by Byzantine mosaics and other decorative arts, such as illuminated manuscripts and ivories. The bold, simplified designs in shallow perspective echoed a response that she and many artists at the time also felt towards the early Italian painting of Piero della Francesca, the Lorenzetti, Sassetta and others.

In the fourth and final year of her M.A. course, Elizabeth had to concentrate on working for her university examinations. This allowed little time for painting but *Flowers in a Black Jug* (Pl. 3) is one of the few pictures she accomplished in that year. The spring arrangement in white, yellow and red was unusual subject-matter for her and it is her only surviving flower painting of this early period.

Despite the pressures of academic work, Elizabeth continued to enjoy all that the college had to offer and made many friends in the painting school. The early 1950s produced a number of lively and talented individuals, among them John Houston, David Michie, David McClure, Hamish Reid and Frances Walker. Elizabeth was introduced to them through her friendship towards the end of her fourth year with John Houston, the man who was later to become her husband.

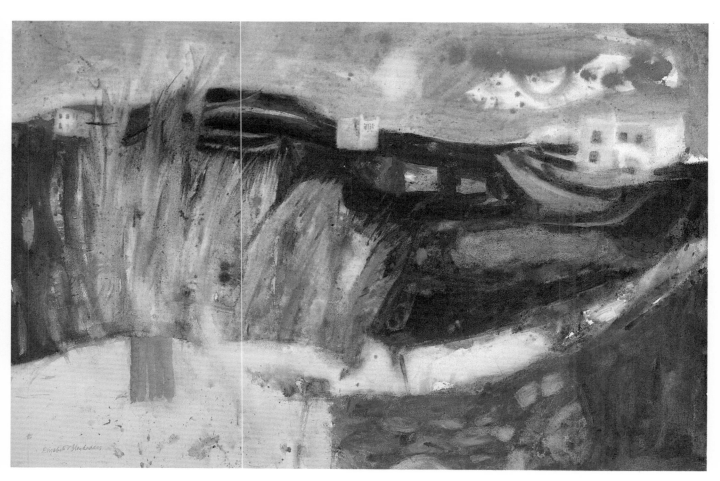

9. *House and Fields, Mykonos.* 1962. Watercolour, 68.6 × 99.1 cm (27 × 39 in). Scottish National Gallery of
Modern Art, Edinburgh

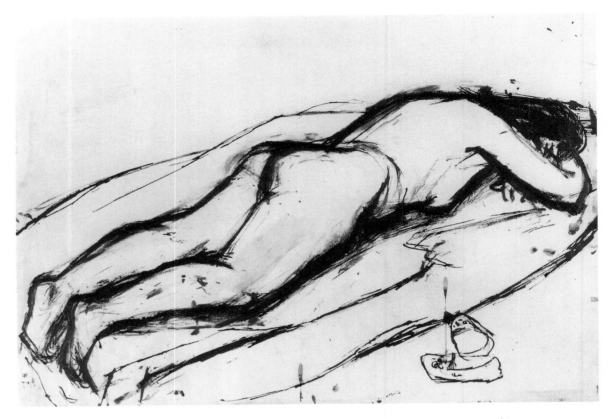

10. *Figure*. 1954. Pen and ink on paper, 38.1 × 55.9 cm (15 × 22 in). Collection of the artist

The fifth and final year of her Fine Art degree was spent in the College of Art. The sombre tones and strong shapes of her oil portraits could also be found in the other pictures she painted that year. Nearly all were edited interpretations of sketches made on local trips and show her struggling to control tone and structure. A few imaginative figure compositions suggest a more adventurous and atmospheric handling of textured surfaces.

Throughout the year she also researched a university dissertation on the artist William McTaggart (1835–1910), the grandfather of her college teacher. McTaggart painted large *plein-air* canvases responding to the moods of the sea and sky and to transient effects of light and in these he explored, quite independently, ideas associated with French Impressionism. Elizabeth must have felt that his hints to young artists, which she quoted in her essay, were of relevance to her own efforts to create a convincingly spontaneous effect: 'The simpler and more direct the method, the finer the picture. . . . Never put a touch on your canvas unless you mean something by it.'

She graduated with a first-class degree in the summer of 1954 and was awarded a Carnegie travelling scholarship by the Royal Scottish Academy and an Andrew Grant Postgraduate Scholarship by the College of Art. As she has said:

The travelling scholarships supported a tradition that students would go away. Many Scottish artists have felt it necessary to leave Scotland from time to time— George Henry, E.A. Hornel, J.D. Fergusson, S.J. Peploe, Anne Redpath, William MacTaggart, William Gillies and John Maxwell, for example. The last two studied in Paris. I suppose we felt we were so far away from the art centres of Europe.

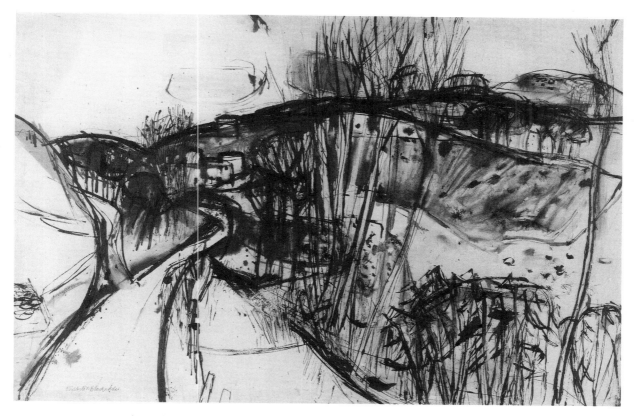

11. *Tuscan Landscape*. 1954. Pen and ink on paper, 50.8 × 76.2 cm (20 × 30 in). Private collection

Artists have commonly travelled in search of the motif. For Elizabeth Blackadder, travel has always satisfied avid visual curiosity: 'I travel because I want to see things, not necessarily to paint. Sometimes the two interests coincide and I may find things I want to paint as well.' Regular journeys abroad, accompanied by an assiduous visiting of museums and galleries on the way, have enabled Elizabeth to build up an enormous repertoire of art historical references. These sources have been absorbed into her visual vocabulary, strengthening her own style and contributing to its personal evolution.

In July 1954 she used the money from her Carnegie scholarship to spend three months travelling through Yugoslavia, Greece and Italy to look at classical and Byzantine art. Her eagerness to explore the sources of Western art was motivated by her academic studies, as well as by the formal development of her work. John Houston was with her and from now on was to be her constant companion on many similar voyages of discovery to Europe, the United States and, latterly, Japan.

The trip, if gruelling and comfortless, lingers nevertheless in their memories as an exciting experience, in which their fascination with Byzantine art and architecture took on a new dimension. Elizabeth's most personal response to her travels is revealed in the sketchbooks she carried. They show her noting the architectural structures of churches, figurative scenes from frescoes, decorative details and objects such as pieces of Murano glass. They also reflect her feeling for the peculiar character of the barren Greek and Italian hillsides, dotted with houses and trees, and for anecdotal detail—fishermen mending their nets, donkeys straining at wooden carts and figures seated on horseback.

During her postgraduate year Elizabeth's figure drawings (Pl. 10) adopt a heavy and strongly sculpted feel that expresses her enthusiasm for the Italian sculptor Marino Marini and for twentieth-century Italian painters such as Giorgio Morandi, Mario Sironi, Massimo Campigli and Antonio Musič. She shared with her contemporaries a liking for the low-key colour range used by these painters and her work that year favoured a restricted palette of browns, greys, black and white with occasional accents of red. Her oils and gouaches, mostly inspired by still-life objects and by sketchbook drawings, transformed rather than described her visual impressions. One of these, an oil painting of a fisherman and two horse-drawn carts, *Aegina*, was sent early in 1955 to the 'Young Contemporaries' exhibition in London, where it hung alongside work by Frank Auerbach, Paula Rego and Joe Tilson, whose painterly attachment to the real world she shared, as well as work by Graham Arnold, her Edinburgh contemporary John Busby and Raymond Briggs. Bought by the education department of the London County Council, it was her first sale to a public collection.

*Aegina Church* (Pl. 13) records a limpid day on which the church is made to glow with singular brightness against the darkened tones of the sky. The painting demonstrates the fluency of her early experiments in watercolour. Elizabeth has always used pencil sparingly to set out selected elements on the paper, leaving the scene to emerge from the free flow of paint on the brush. Although more refined and infinitely more assured, this manner of handling the medium, characteristic of the Edinburgh School, has scarcely altered in the course of Elizabeth's career.

In the case of her oil paintings, distant echoes of Edvard Munch can be caught both in the contrasts of light and dark and in the rhythmic lines of the design itself. They account, in part, for the strangely brooding air her northern imagination brings to the southern world. When five of her oils were shown in the summer of 1955 in 'Eight Young Contemporaries', an annual talent-spotting exhibition organized by Gimpel Fils Gallery, *The Times* critic was moved to observe that 'her landscapes, rich in texture and sombre in tone, are filled with a lyrical and melancholy poetry.'

Elizabeth received high commendation for her postgraduate diploma show and was awarded a further Andrew Grant scholarship to travel abroad for nine months. She returned to Italy, spending most of her time in Florence. As she herself says, she was 'very catholic' in her tastes and was actively 'looking at everything—buildings, sculptures, painting, Etruscan pots and the haloes of saints and their symbols'. Every day she crossed the *pasarella*, the temporary wooden bridge thrown over the River Arno after World War II. Her watercolour *Bridge, Florence* (Pl. 14) echoes her impression of that city in its use of earth colours, her favourite palette at that time.

Despite the bitter winter, she achieved a large number of drawings and watercolours of Italian townscapes and landscapes during her stay. Her gouaches and drawings in the Tuscan hills evoke the pattern of the winter landscape, with its ridges and indentations, in muted colours of grey, brown, ochre and dirty green slashed dramatically by passages of black and white paint. At the time she was using a great deal of white with pure colour, which lent her landscapes a solid chalky appearance.

A new austerity, apparent in the gouaches, signals a departure from the emotive handling of some of her Greek subjects and a newly focused interest in forms and structures. Again and again she returned to draw and paint the majestic architecture of Florence cathedral, sometimes climbing up the campanile to look down onto the building from a height. She adopted a similar, all-embracing vantage point for many of her town- and landscapes, often luring the eye in through a street or road, so that the physical experience of the scene is immediate.

By contrast with the still, sculpted look of her figures at that time, the drawings in pen and ink and in pencil of city and countryside are very freely expressed and take on a movement and life of

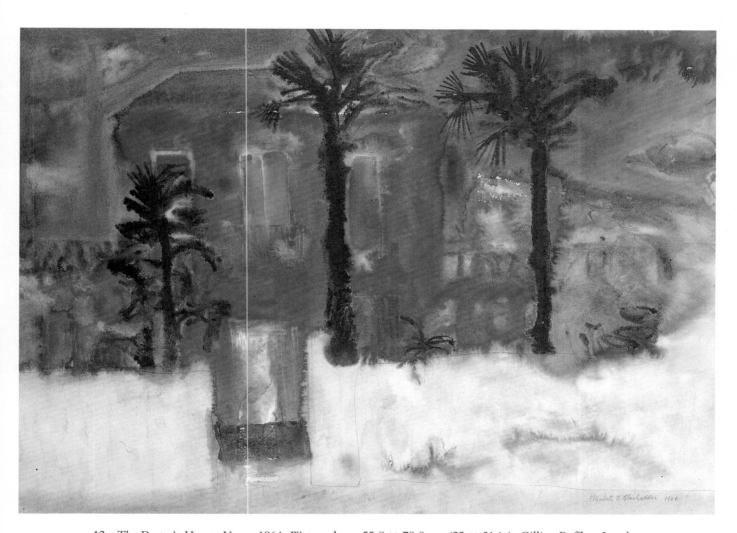

12.  *The Doctor's House, Vence*. 1964. Watercolour, 55.8 × 78.8 cm (22 × 31 in). Gillian Raffles, London

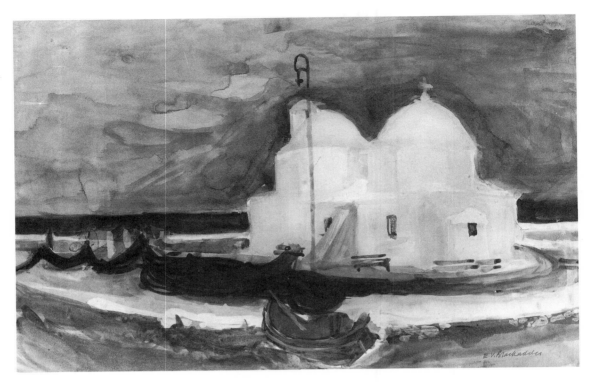

13. *Aegina Church*. 1954. Watercolour, 29.2 × 45.7 cm (11½ × 18 in). Private collection

14. *Bridge, Florence*. 1955. Watercolour, 58.4 × 86.4 cm (23 × 34 in). Collection of the artist

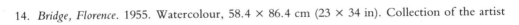

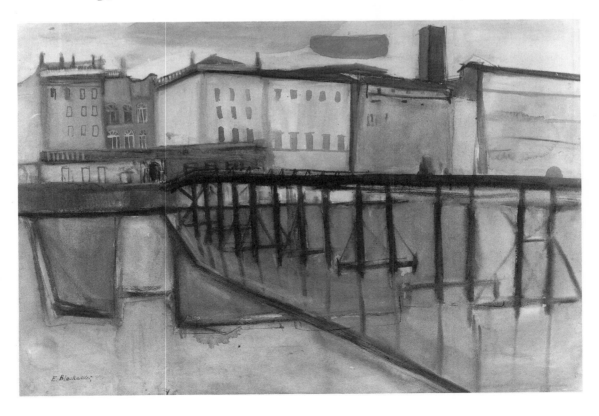

their own. In *Tuscan Landscape* (Pl. 11), houses, tucked into odd angles and folds, hug the slope of the hills. Elizabeth senses the sweep of the land as a single rhythmical curve continuing beyond the picture frame. The speed and energy of the hand and eye leave their mark in the bold reworking of lines and in splutters of the pen.

William Packer discerned how close she was temperamentally to the preoccupations of English artists when he wrote in the catalogue to her 1981 retrospective exhibition of 'an authentic whiff of mid-fifties graphic romanticism, with its flattened forms, emphatic contours and strongly patterned surfaces—as it might be by Ayrton, Craxton and Minton out of Graham Sutherland'.

When Elizabeth Blackadder returned to Edinburgh in March 1956, William Gillies offered her a two-year, part-time teaching contract in the College of Art, where John Houston was also an assistant. Whenever possible, such opportunities were created by the college for its most talented students and, although such gestures have been criticized, they plainly both supported and encouraged its artists and introduced fresh young ideas to its teaching.

# Building a Career

John Houston and Elizabeth Blackadder were married in August 1956 and bought a flat at 7 London Street, a late Georgian building in Edinburgh's New Town. It was a particularly happy find, for it brought them into the company of Anne Redpath, a doyen of the artistic establishment, who lived in the flat immediately below them. At the time she was painting still lifes and interiors of an intense coloration and surface richness that Elizabeth greatly admired.

Marriage to John Houston, an artist as thoroughgoing in his convictions as herself, gave Elizabeth considerable encouragement to pursue her own artistic ambitions. The partnership was uncommon and it continues to impress their friends with its single-minded commitment to work and with the mutual support, both moral and practical, that John and Elizabeth render each other. Despite many shared aesthetic interests and a close personal involvement with each other's achievements, they have maintained their professional independence. As an artist John Houston has always been strongly affected by Edvard Munch and by German Expressionists such as Paul Klee, Ernst Ludwig Kirchner and Emil Nolde, and his evocative oils and watercolours continue to give heightened expression to his feelings.

The Houstons' lives revolved around art: teaching in the college according to the demands of the timetable and painting at every available opportunity. Elizabeth returned to the stimulus of her Greek and Italian sketchbooks for her drawings (Pl. 16) and as a basis for finished paintings. The cities of Florence and Assisi and the Tuscan landscape remained favourite themes, and watercolour was as important a means of expression as oil. Her desire to use pure watercolour may partly have contributed to her move towards a more colourful palette. Her first bowl of brightly coloured fruit isolated on a white ground was in gouache and this was followed by compositions in oil that anticipate the vivacious harmony of colours and forms that emerge in the work produced after a late summer visit to Spain in 1958.

The paintings of the late 1950s mark a significant change of emphasis in her work. It was not, however, a sudden change of direction. There have never been any sudden or critical turning points

15. *Two Women at Nazaré.*
1967. Oil and oil pastel,
26.7 × 36.2 cm (10½ × 14¼ in).
Private collection

in Elizabeth Blackadder's development as an artist, which evolves by subtle shifts and by a reflective exploration of ideas. What has happened is that subjects once distinguishable as interiors or exteriors, as narrative, landscape or still life, can no longer be so clearly defined. For one thing, the images are not located in any realistically described space. Her pictures are now *dis*placed compositions, redolent of some deeply felt experience, or combination of experiences, and rich in associations. There is pleasure, too, in rediscovering the mystery surrounding everyday things which, just because of their familiarity, often go unremarked.

A visit to an Italian church in 1954 left a lingering memory of a small gilt figure holding a candelabrum. That isolated detail of a visit long since past, resurfaced some six years later in an unusual watercolour, *Altar, Lucca* (Pl. 17). As a student Elizabeth revealed a passion for Turner and we sense something of his obscure vision in the spontaneous gestures that both blur and define the forms and in the delighted interplay of opaque and translucent paint.

Another work of around 1960, *The Basilica* (Pl. 18), suggests a similar ambiguity. A transition has taken place from the formal simplicity of the Italian Romanesque facades painted on her return from Italy to an assemblage of favourite and quite specific details: ornamental Cosmati work, delicate Renaissance arcading, rose windows and pierced stonework. Much of the excitement of *The Basilica* derives from the imaginative handling of the pigment, creating textural surprise across the surface of the canvas.

Elizabeth has always turned readily from one form of expression to another to render different aspects of experience in a fresh and direct manner. The immediacy with which she set down her ideas in the 1950s lent itself to the post-war revival of art lithography. In 1957 she was one of fifteen artists invited by the Scottish Committee of the Arts Council to design fine art lithographs at

16. *Baptistery, Pisa*. 1956. Pen and ink on paper, 49.5 × 74.9 cm (19½ × 29 in). Private collection

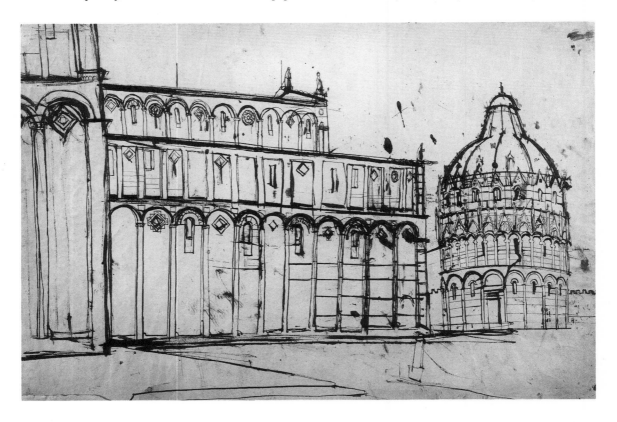

 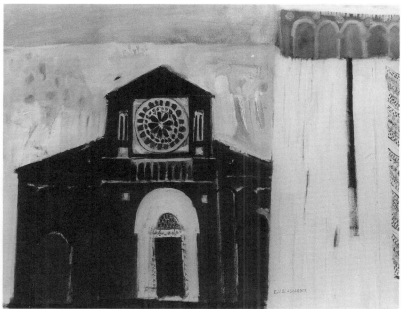

17. *Altar, Lucca. c.* 1960. Watercolour, 67.3 × 62.2 cm (26½ × 24½ in). Glasgow Art Gallery and Museum

18. *The Basilica. c.* 1960. Oil on canvas, 71.1 × 91.4 cm (28 × 36 in). Private collection

Harley Brothers, an old established Edinburgh firm of commercial litho printers. While working there she met Robert Erskine, owner of St George's Gallery in Cork Street, London, who commissioned a group of landscape prints from her, including a series on Hadrian's Wall. Their success led to two further commissions. One came from the Museum of Modern Art in New York for a landscape subject of her own choice; the result was *Dark Hill, Fife* (Pl. 21). The other commission was from the Post Office for a lithographic view of *Staithes, Yorkshire* (Pl. 22), which was to be used for a poster in an advertising campaign aimed at encouraging the public to address mail correctly.

As Harley Brothers had gone out of business, Erskine arranged for Elizabeth to execute these two lithographs in London at the newly opened Curwen Studio in Plaistow, where she worked with a highly skilled printer, Stanley Jones. Jones observed her 'natural facility for exploring and exploiting her ideas on the stone' and appreciated the importance of preparing the stone to retain the fine, delicate qualities of her watercolours. The freshness of her touch kept the images alive through the various processes, sustaining the energy of the Yorkshire drawing and imposing a muted wintry mood on the dark hill in Fife, bare but for a few cows. The poster of Staithes has a romantic, slightly mannered English air, but it displays a painterly breadth traditional to Scotland.

Like other young artists attempting to build a career at that time Elizabeth Blackadder found disappointingly few outlets in Edinburgh for showing work to the public. Encouraged by William Gillies and Penelope Beaton she had already had small works accepted for the 1955 annual exhibitions of the Royal Scottish Academy and the Royal Scottish Society of Painters in Watercolour during her postgraduate year. Thereafter, she regularly submitted work to both these bodies and to the Society of Scottish Artists, although it was not always selected for exhibition. She was showing annually with all three from 1958, but remembers selling little or nothing.

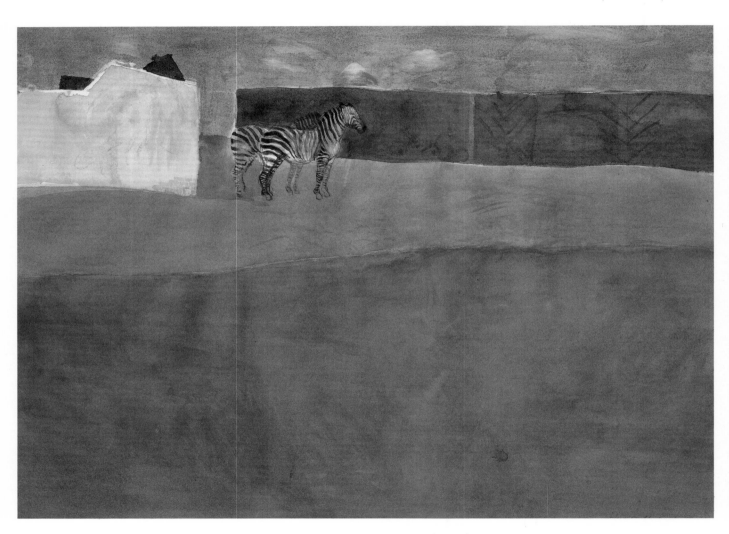

19. *Zebras*. 1969–70. Watercolour, 56.5 × 77.5 cm (22¼ × 30½ in). Private collection

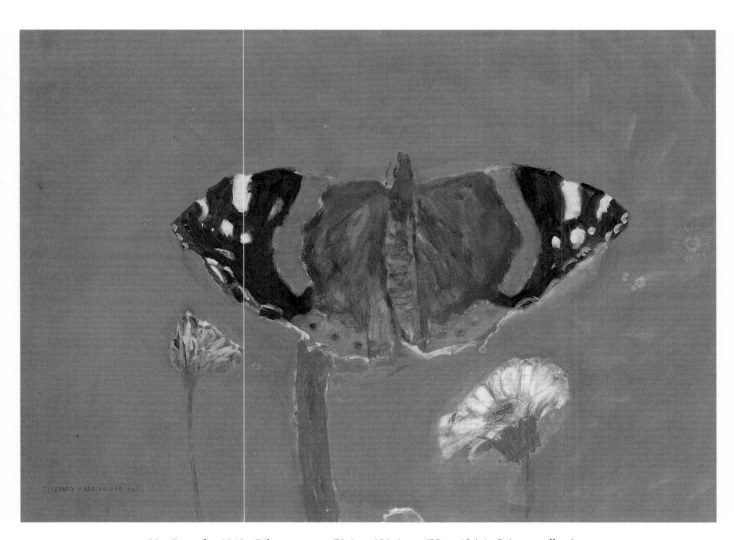

20. *Butterfly*. 1968. Oil on canvas, 71.1 × 101.6 cm (28 × 40 in). Private collection

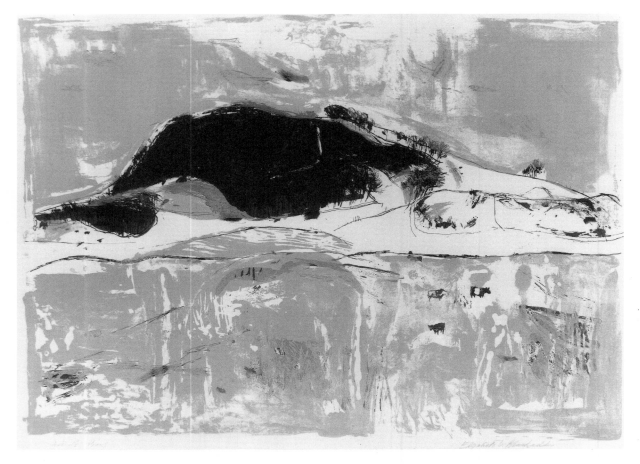

21. *Dark Hill, Fife*. 1961. Lithograph, 47.9 × 67 cm (18⅞ × 26⅜ in). Museum of Modern Art, New York

In response to the need for an alternative space for young and experimental artists to show their work, the 1957 Gallery was established by Daphne Dyce Sharp as an artists' co-operative under the chairmanship of Patrick Nuttgens, a former student of architecture at Edinburgh. It was here that Elizabeth Blackadder had her first one-man show in 1959 and acquired a few patrons.

Elizabeth was exploring intuitive abstract means of painterly expression, but her images remained representational and, as such, sufficiently sympathetic to the Edinburgh tradition to gain a place on the Academy walls and, in 1961, to be hung in The Scottish Gallery. The Director, Mrs Proudfoot and her partner, William Macaulay, invited her to have a one-man show which comprised over fifty works—landscape, still lifes and figure groups—in oil and watercolour. The exhibition received a highly flattering review from *The Scotsman*'s critic, Sydney Goodsir Smith, who, lavishing special praise on her landscape watercolours, concluded: 'I am sure watercolour is her true medium. She has a poetic vision and a light, fairy touch that seems to suit better the lighter medium.'

Three years earlier her prospects for pursuing a career as an artist had looked anything but lucrative or certain. In the summer of 1958 her two-year part-time teaching contract with the College of Art came to an end. She took a two-term course at Moray House Teacher Training College and was engaged in the summer of 1959 as an art assistant at St Thomas of Aquin's girls' secondary school in Edinburgh, where she taught for four terms. An offer then came from

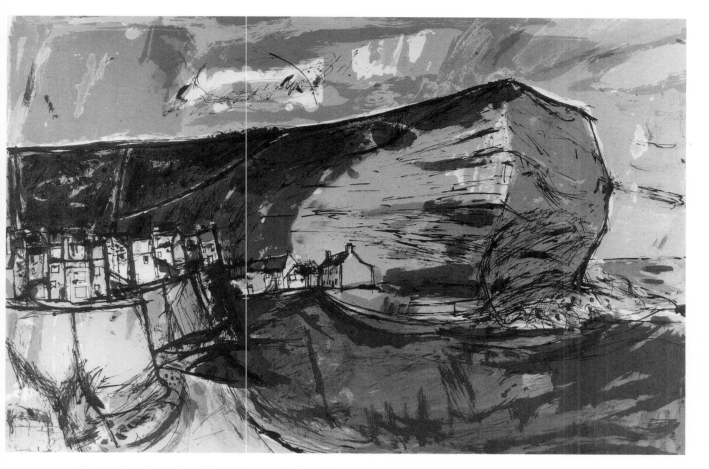

22. *Staithes, Yorkshire*. 1962. Lithograph, for a G.P.O. poster, 58.4 × 91.4 cm (23 × 36 in). Private collection

Professor Talbot Rice to work in the university's Fine Art, Prehistoric and Classical Archaeology departmental libraries. It was a stimulating experience, bringing her into daily contact with books, which were and remain a continuing source of pleasure and inspiration.

In 1962 Elizabeth's painting *White Still Life, Easter* (Pl. 8) was hung in the Royal Scottish Academy and won the Guthrie Award for the best painting by a young artist. She decided to relinquish her library post from the end of that summer in order to devote more time to painting and, later the same year, was offered part-time teaching at the College of Art by Robin Philipson, successor to Gillies as head of the Drawing and Painting School.

Return to the college environment was an invigorating spur to her own work, and Elizabeth devoted herself to refining a pictorial language typified by *White Still Life, Easter*. This is a sparkling painting, whose monochrome contrasts are enlivened by brilliant little explosions of colour. The paint-encrusted canvas is richly conceived and conveys an overall sense of occasion despite its apparent sparseness: a heavy curtain is pulled back from a table to disclose a row of ornamental objects, including a decorated egg in a cup. The interpretation is imaginative, for there is no desire to be realistic. Despite the picture's title, its theme is seasonal and associative, rather than religious in any Christian sense: a vision of rose windows, mosaics, fragments of tracery and of ornamental cloth and small personal icons like the egg and cup, wooden box and goblet which are still in her studio.

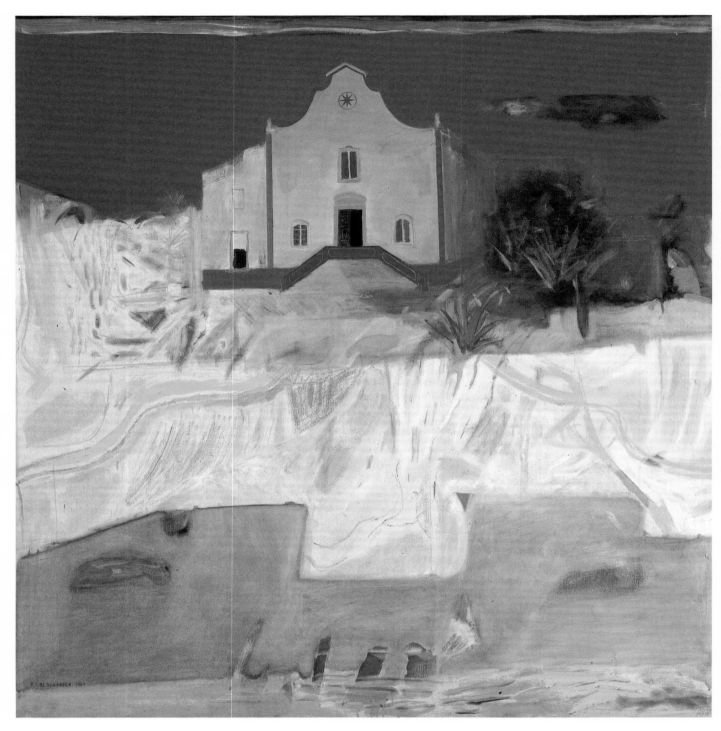

23. *Church at Ericeira*. 1969. Oil on canvas, 127 × 127 cm (50 × 50 in). Robert Fleming Holdings Ltd.

# Developing a Language

The grammar of what we recognize today as Blackadder language was acquired early. In Elizabeth's final and postgraduate years at college the still-life gouaches she was painting already show her breaking away from conventional groupings and spreading the objects out on the paper. The idea of balancing one individual form against another in an apparently random arrangement is reminiscent of pre-Christian paintings and mosaic floors. Elizabeth's device is the one most commonly used by still-life painters since the Renaissance, the table top, but like many twentieth-century artists she tilts its surface up towards us, simplifying and flattening the forms displayed against it and rendering them at their most typical: head-on, slightly from above, or simultaneously, as in Cubist paintings, from both points of view.

Elizabeth admired the optical effects achieved by employing more than one perspective in the version of Paolo Uccello's *The Battle of San Romano* which she saw in the Uffizi in Florence. However, her own *mis en scène* had closer affinities with the tightly compressed space in Georges Braque's paintings of the 1920s. Like Braque, her method of composing was largely additive and intuitive. He described it as 'an adventure': 'I discover my picture in the canvas the way a fortune teller reads the future in tea leaves.' Elizabeth, too, acknowledges the element of chance and luck in painting as in life, an attitude which explains her readiness to exploit the accidental effect. Indeed, she actively invites it by posing herself visual problems and then taking calculated risks in their solution.

Early Italian predelle, the sequence of small narrative paintings hanging beneath main altarpieces, offered another source of pictorial ideas. Elizabeth was particularly intrigued by paintings of tables covered by a cloth, whose whiteness enhanced the pattern of objects laid casually on its surface. She noticed, too, that the spellbinding power of one of her favourite paintings, Hieronymus Bosch's *The Conjuror*, which she had seen reproduced from a French collection, emanated from the tension set up between the strange objects on the table and the mesmerized onlookers.

These ideas have been a continual source of inspiration and were some of the immediate stimuli for her white pictures of the late 1950s and early 1960s, most notably *White Still Life, Easter* and a group of hazy gouaches inspired by Byzantine domes and facades, that chase the evanescent effects of light and atmosphere in *Altar, Lucca*. Elizabeth later offered the following explanation of her early experiments with pictorial language:

> Because still life was one of the set subjects on the curriculum when I was a student and because a lot of the painters I liked, such as Morandi, Braque, Matisse and Picasso, painted still lifes, it seemed a very natural thing to do. And then I began to realize that it wasn't the idea of painting objects that interested me, but of using the subject as a means of exploring all kinds of visual imagery and other ideas in an abstract way without being held to any kind of realism.

Anne Redpath used to relate the imagined life of cups on a table to that of houses in a landscape. Although Elizabeth herself never discusses her work in this way, the compositional devices of her early landscapes, in which the scene is laid out before her, were much the same as those encountered

33

in her still lifes. If pure landscape painting allowed her fewer liberties with perspective composition, it also tested her powers of selection and invention. Perhaps for this reason she developed a type of landscape painting in which structures are simplified and even distorted and in which shapes themselves define space. Her sense of what transforms a landscape into a picture is based on its formal elements and out of these she conjures atmosphere, rather than a clearly identifiable place.

Throughout the 1960s Elizabeth Blackadder made a large number of drawings and paintings of landscape in Scotland and in southern Europe. In the late summer of 1962 she and her husband returned to Greece to see classical and Byzantine sites at Delphi, Olympia, Delos, Mycenae, Daphni, St Luke in Phocis, Mistra and other places, some of which had been virtually inaccessible by public transport in 1954. A detailed outdoor sketch made in Mykonos shows stone buildings, a white-topped stone wall snaking through the fields, coloured rugs spread out to dry on the ground and a clump of tall reeds. Back in Scotland Elizabeth used this drawing as a basis for the watercolour painting *House and Fields, Mykonos* (Pl. 9), in which she re-created her spontaneous response to the texture of the land by blending her watercolours wet into wet. She wiped or soaked the pigment off repeatedly, sometimes dipping the sheet of paper in the bath, a process that left an exciting pattern of ghost-like stains and trails. Some of the most startling shapes have been formed negatively by sponging away the colour, enhancing the luminosity of the scene.

The dark and light contrasts that Elizabeth Blackadder relied on to create an expressive harmony in her watercolour landscapes are even more severe in the oil paintings she did on her return from that visit to Greece and Turkey in 1962. It is true that she sought out the starker side of nature in response to her own feelings, but time has crystallized the memory to one of harsh light cast over a land baked by the heat, its cornfields bleached to a creamy whiteness. In her paintings of Mykonos and Mistra there is a strong sense of the presence of the land and a selective use of pictorial imagery, particularly the decorative detail of buildings. Like many modern artists she turns to simple, basic forms. Her sensibilities are stirred by the crouching shapes of hills and valleys that yield a clear sense of their anatomy and out of which buildings crop up in bone-like protrusions.

The paintings of this period exemplified the independent direction in which Elizabeth Blackadder's work had been moving since the mid-1950s, and the attention they drew was highlighted in her eventful thirtysecond year. In 1963, she was elected an Associate of the Royal Scottish Academy and her achievement was recognized by the inclusion of her work in two important surveys: '20th Century Scottish Painting', organized at Kendal by the director of Abbot Hall Art Gallery, Helen Kapp, and '14 Scottish Painters', selected for exhibition at the Commonwealth Institute in Kensington by Eric Newton.

Following the exhibitions in Kendal and London Elizabeth received favourable, if brief, mention in the national press, *The Times* critic in his review of the Scottish painting at Abbot Hall describing her as 'a watercolourist of distinction'. As her qualities became more widely acknowledged, her work came to the notice of a dealer who had recently opened the Mercury Gallery in Cork Street, where in 1965 she was given the first of many one-man shows in London. The exhibition marked the beginning of a long and successful association with the Mercury Gallery and of loyal and steadily expanding patronage.

Elizabeth's first one-man show at the Mercury Gallery included paintings inspired by a visit made the year before to the French Riviera. She had been drawn there as much by a wish to visit her grandfather's grave in Nice, as to see the country painted by admired artists such as Picasso, Matisse, Dufy, Chagall, Bonnard, Renoir, Cézanne, Soutine and Max Beckmann. She found the landscape blackened by summer fires, but prompted by these artists' example, she began to heighten the colour of her own paintings. Her approach is still reductive, paring forms to their

essentials. The palette is still limited, but experimenting first in watercolour she begins to explore new and rich colour harmonies. *The Doctor's House, Vence* (Pl. 12) is one of several freely painted watercolours in which edges are blurred and forms merged in a subjective composition. Elizabeth was intrigued by the simple, rectangular, red-washed building, by the symmetry of the palm trees and by the rhythms these strong vertical forms brought into play with the shutters.

She returned to the South of France the following year, 1965, to look at art collections and to draw and paint figures and landscape. The principal theme of these paintings was bathers, bathers at Nice and on the Esterel coast, where the colour of the red porphyry rocks could be given its due by exaggerating the jade green depths of the sea and where the naked bodies of plunging bathers seemed to absorb the vivid colours of rocks and water. On that second trip to the South of France Elizabeth included oil pastels among her painting materials and experimented with the solid and sonorous hues obtained with them.

The small-scale works she accomplished that summer look forward in their simplicity to pictures made the following year in Portugal. In the old fishing port of Nazaré the fishermen wore bright checked shirts in a design similar to Scottish tartan and the women, billowing skirts with jazzy shawls and headscarves. Elizabeth was fascinated by the casual groups formed by the women on the beach as they sat chatting and waiting for the men to bring in the boats. The older figure, who is the centre of attention in *Two Women at Nazaré* (Pl. 15), makes a more sombre impression in her black dress and kerchief. Graphic embellishments with oil pastels add a more strongly patterned flavour to her design than the subtle marks made with oil paint and the visual appeal of these small-scale works is not unlike the richly decorative effect of Indian miniatures which Elizabeth admired.

Drawn marks are the distinguishing feature of a tapestry commissioned by Mrs John Noble of Ardkinglas for the National Gallery of Modern Art (Pl. 24). The cartoon for the work consisted

24. *Untitled Tapestry.* 1967. Woven by Edinburgh Tapestry Company, 170.2 × 243.8 cm (57 × 96 in). Scottish National Gallery of Modern Art, Edinburgh

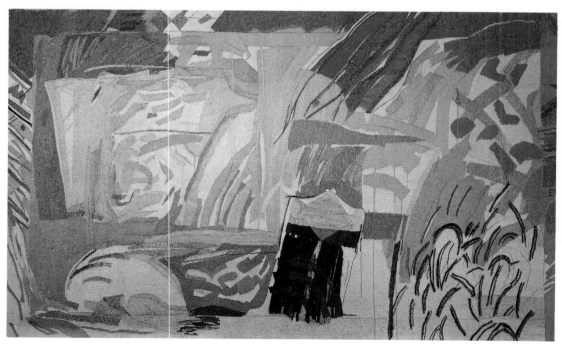

entirely of drawing in chalk and pastel with delicate watercolour washes. An abstract vocabulary lent itself particularly well to an imaginative translation into the language of weavi embroidered stitching known as *ressaut* work to enhance some of the decorative motifs. cartoon left areas of unpainted paper, the weaver, Maureen Hodge, has rendered the s variety of white yarns and has even made a decorative linear feature of the paint run

Elizabeth has always preferred to work from some point of reference and the tapes remains her one and only excursion into total abstraction. Invariably, she incorporate pattern into the picture-making process itself and, in doing so, she employs an in eloquent language of shorthand derived from pieces of fabric, ribbons and decorative i These may suggest hills or houses, bumps in the ground or folds in a table cloth. Or simply be there to articulate the design.

Requiring more studio space, John and Elizabeth had moved at the end of 1963 detached house in Queen's Crescent, Newington, where the acquisition of a sm encouraged them to cultivate plants. The energetic pen drawing, done in 1966, of a grown in the garden (Pl. 25), was one of the earliest examples of her revived interest in and recording plants. The scrutinizing eye that she once turned on the human frame architecture of Florence cathedral is now turned on aspects of the natural world, the s crabs and lobsters, artichokes and flowers.

25. *Lilies*. 1966. Pen and ink on paper, 61 × 55.9 cm (24 × 22 in). Private collection

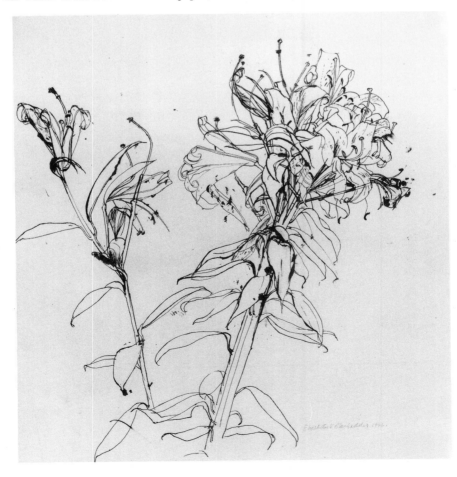

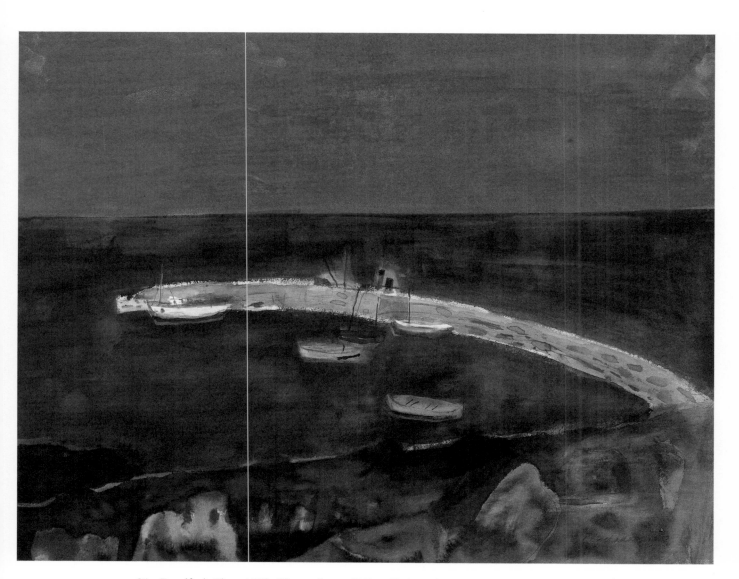

26. *Broadford, Skye.* 1970. Watercolour, 45.7 × 58.4 cm (18 × 23 in). Private collection

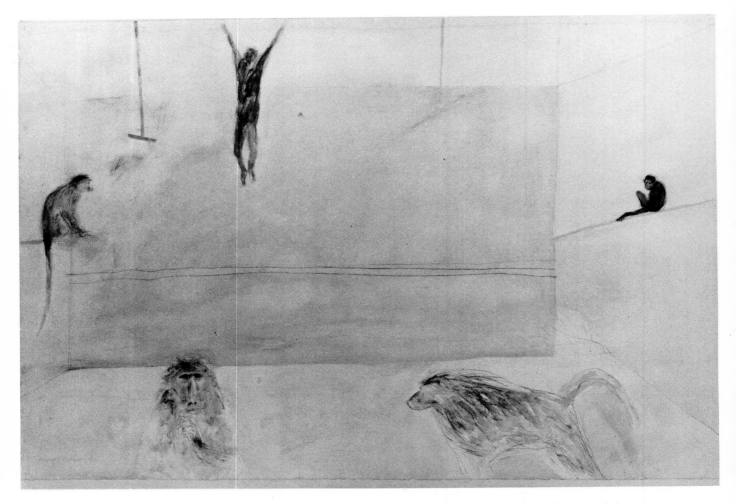

27. *Monkey House.* 1972. Watercolour, 68.6 × 101.6 cm (27 × 40 in). Collection of Vincent Price

From the mid–1960s animals, birds, butterflies and moths find their way more frequently into Elizabeth's pictures and are observed with the same mixture of affection and detachment as the human figure or a still-life object. There is no doubt that she enjoys the shapes, poses and movements of animals and is amused by their behaviour, but her pictures are not about animals in any scientific sense. The large oil painting *Butterfly* (Pl. 20) is not intended as an analytical study of a particular species, the Red Admiral. Her attention was arrested by the way its scarlet and black markings were enhanced by the complementary green of the plants as it hovered, wings outstretched, over a flower.

From visual observation alone Elizabeth extracts the essential characteristics of a particular animal and starts composing with, say, the gymnastic performance of a monkey (Pl. 27), the pattern of zebra stripes (Pl. 19), or the slow relaxed curve of a cat's back (Pl. 28). The focus of attention will come to rest on a paw, as it might on a jug or a box. The suspended swing of a monkey and its potential for movement creates the same tensions across the paper as a switch of ribbon in a still life, or the line of a wall weaving through the landscape.

The use of a single large image such as the butterfly or a pair of zebras side by side is rare in Elizabeth's work. A chosen subject will usually trigger an assembly of many other objects from

around the home or studio. Favourite jugs, coffee pots, bowls of real or glass fruit, agates, small wooden boxes and painted eggs, egg cups and postcards were all familiar and recurring themes in the 1960s. Each object is examined individually before being placed in a composition scattered over what is still just identifiable as a table.

The bright ribbon-like motifs that recur in Elizabeth's work at this time act in her landscape paintings in much the same way as they do in her still lifes, moving the eye from plane to plane and vitalizing the scene. There are other similarities, too, between still life and landscape. *Church at Ericeira* (Pl. 23), for example, is composed with the same horizontal emphasis, the same three-tier division and the same firm limitation of space. She retains the naturalistic form of the landscape, but concentrates even more on abstracting and distorting shapes, such as the strange angles of the road in the foreground, and on creating mood with daring combinations of non-naturalistic hues. The top-heavy intensity of the blue sky with its magenta clouds, establishes a peculiarly rich foil to the shimmering Baroque facade of the Misericordia church. At the same time it brings the distant building into surprisingly close focus.

28. *Abyssinian Cat Asleep.* 1975. Pencil on paper, 38.1 × 50.8 cm (15 × 20 in). Private collection

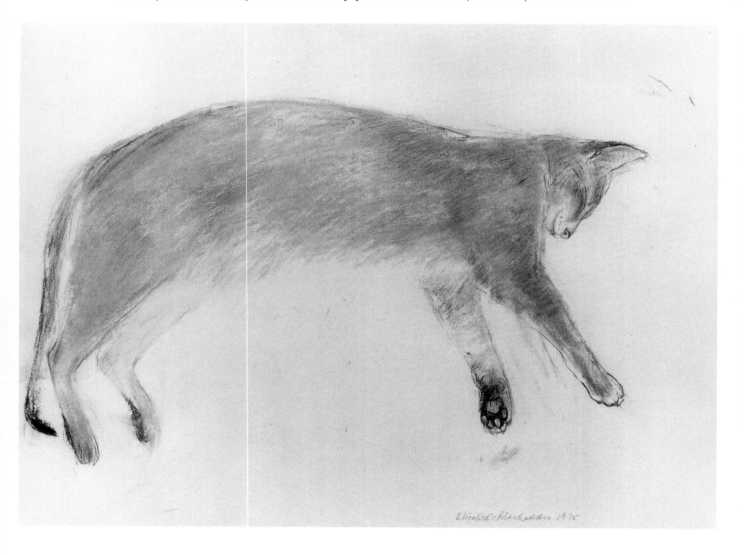

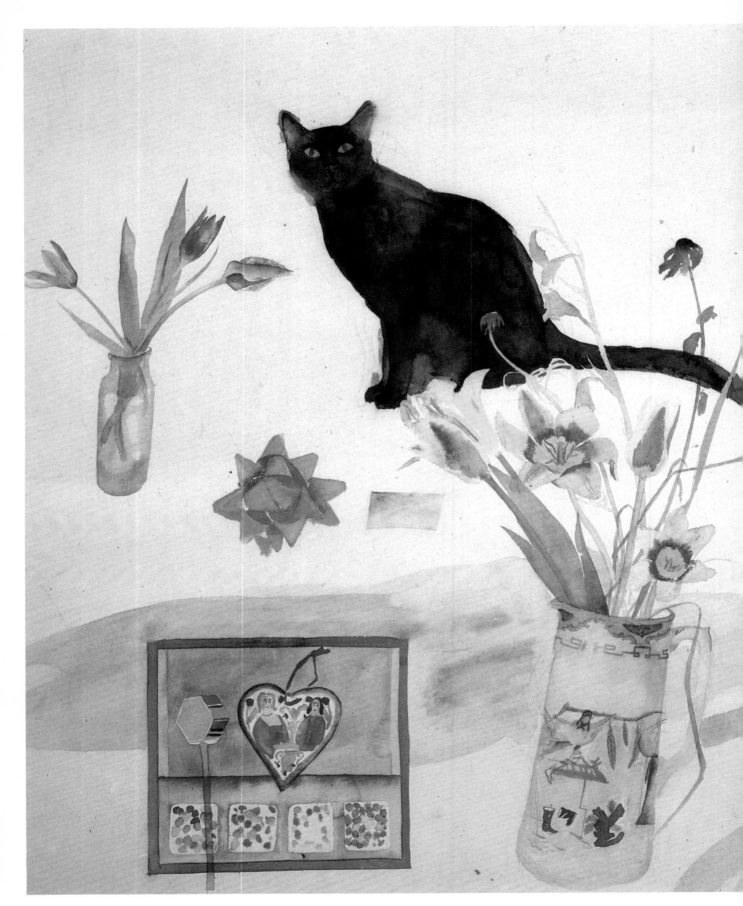

29. *Cats and Flowers*. 1978. Watercolour, 78.7 × 133.4 cm (31 × 52½ in). Towner Art Gallery and Local History Museum, Eastbourne

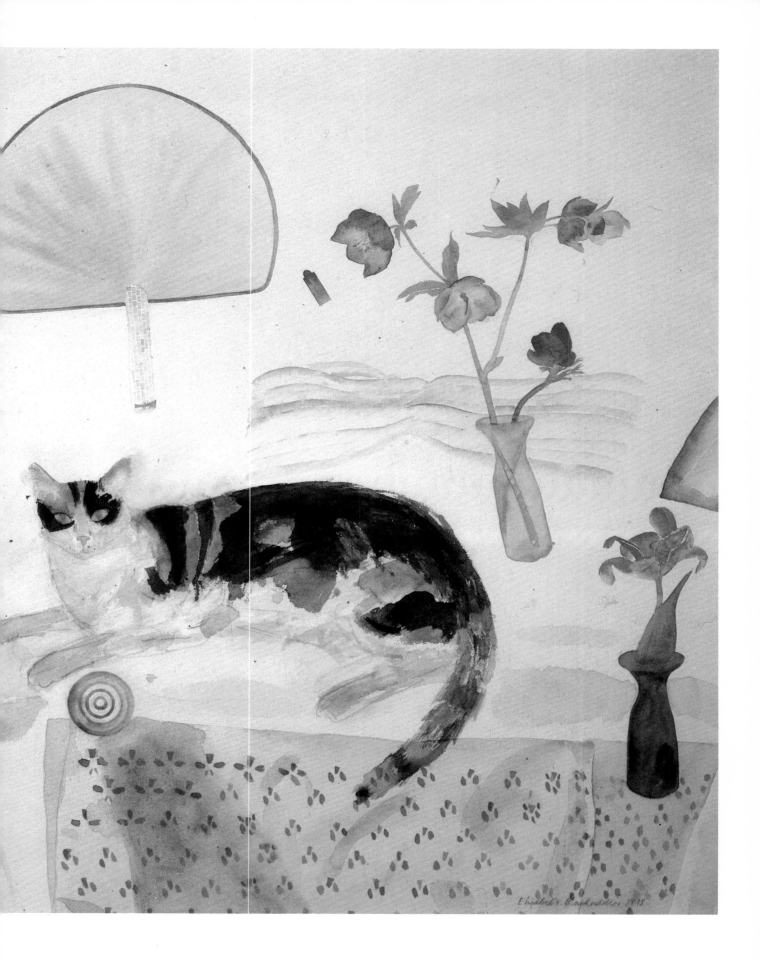

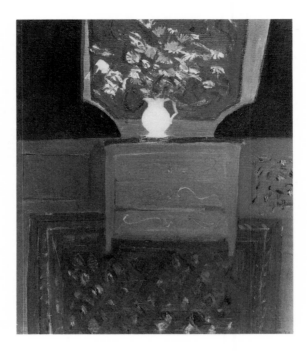

30. *Yellow Chest of Drawers*. 1969. Oil on canvas, 61 × 50.8 cm (24 × 20 in). Private collection

In Elizabeth's interiors, furniture—chests of drawers, chairs, cupboards and carpets—is deployed much as buildings are in her landscapes. The compositions themselves are carefully structured, one shape piled upon another or slotted into another. *Yellow Chest of Drawers* (Pl. 30) celebrates a favourite piece of painted furniture decorated with blue arabesques. She orchestrates its shape and colour with the bulbous white vase, the red and green Spanish rug, and the flickering coloured lines that activate this otherwise still interior.

# Eastern and other Encounters

Elizabeth's delight in the foreign objects collected by her grandfather could be interpreted as the sort of obsession any child might have with curiosities. Yet it was clearly more than a passing craze. Strange and exotic objects of many kinds continued to exercise a peculiar hold over a sensuous and strongly imaginative nature. While studying in Edinburgh she grew to appreciate the qualities of non-Western art, but several years passed before she discovered a way of fusing her academic and practical interests and of incorporating them into her pictures. The models invoked by the Edinburgh School of artists suggested a means of doing so. It was perhaps inevitable that Elizabeth's attempts to find a personal and contemporary mode of expression should have been shaped by her teachers, who were interested in early Italian painting, and in Impressionism and Post-Impressionism.

She first became aware of the brilliance of the colours handled by Indian and Persian

miniaturists when she visited the Indian collection in the Victoria and Albert Museum in 1954, and she relates her early enthusiasm for Indian art to an interest 'general among Scottish artists for colour and the use of colour'. Her enjoyment of ornamental tendencies in painting led her quite naturally from Bonnard and Vuillard to an appreciation of Matisse, whose partiality for Japanese silks, Persian carpets and Islamic and oriental vessels matched her own predilection for exotica.

Besides the French colourists she found herself looking at the work of Western abstract artists such as Sam Francis, Mark Tobey, Adolph Gottlieb and Julius Bissier, who found fresh inspiration in the art and meditative philosophy of the Far East. By the end of the 1960s Elizabeth's own painting was responding directly and personally to the experience of Eastern art. She drew on its pictorial vocabulary and, increasingly, on its artefacts as subject-matter for her still lifes.

Regular trips abroad stimulated and enhanced the pleasure of collecting for her home as well as providing the impulse for still-life paintings.

> My interest in collecting, which started when I was a student, went hand in hand
> with what I was trying to achieve in my painting. At first I looked out for jugs
> with interesting patterns or special associations. I've always liked embroidery and
> rugs, especially Eastern rugs with their formal decorative shapes, even the
> symbolism in them. And I've tended to collect just pieces of material if the pattern
> appealed to me.

The acquisition of several Persian rugs in 1964 inspired a series of paintings, which played off the cool white interiors of mosques against the rich colours and formal designs of the carpets.

A visit to London in 1964 stimulated Elizabeth Blackadder's collecting in a new direction. She bought some small carved wooden animals and figures recently imported from India and was later to acquire more Indian toys and boxes in Paris. American Indian jewellery, Mexican fans, Chinese paper kites, Japanese waterflowers and puzzles, luridly patterned lollipops and other colourful bits and pieces of a kind eagerly sought after by Pop artists and designers were all collected as she came across unexpected novelties in London and Edinburgh shops. These purchases launched what was to become an extraordinary treasury of decorative kitsch. By the end of the decade it provided the elements of a new and very personal subject-matter for still-life painting, triggering more and more elaborate configurations such as *Still Life with Japanese Puzzles* (Pl. 33). The table top has disappeared from these paintings and with it familiar domestic items. Instead, exotic toys and trivia are related in a mysterious and abstract way and move in an unidentifiable space.

In Edinburgh Elizabeth also found a utilitarian assortment of Chinese pencils, sharpeners, erasers and a Chinese lacquer picnic basket which subsequently appeared in a number of paintings (Pl. 34). 'I liked their shapes, but also their purposes,' she explains.

On a visit to the United States in 1969 Elizabeth went to see the rich collections of oriental art in the Freer Collection in Washington and the Art Institute of Chicago. She remembers the occasions as two of her most exciting encounters with Far Eastern art, giving her new insight into the oriental way of looking at the world: 'The abstract feeling of the designs; a screen perhaps just decorated with floating shapes of fans or other objects; the use of gold leaf and the beautiful, precise drawing of flowers, birds and animals which seem to catch their essence.'

The simplicity of oriental design, its tradition of making a small detail of life stand in for a whole experience and of allowing it to carry the symbolic weight as well as the passing pleasure of that experience, gave strength to her compositional ideas. In *Broadford, Skye* (Pl. 26) she creates her own quiet drama from the forceful gesture made by the stone wall as it curves across the flat expanse of water. Like Hokusai, she conceives the dynamic composition in almost abstract terms,

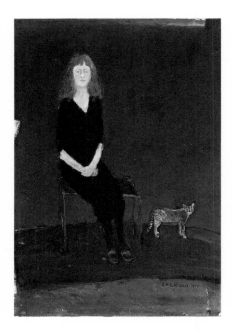

31. *Girl in a Black Dress.* 1977. Oil on board, 34.9 × 22.9 cm (13¾ × 9 in). Mr and Mrs William Jackson, The Scottish Gallery, Edinburgh

while evoking the familiar dampness of a Hebridean morning, boats moored peacefully in the bay.

Elizabeth's paintings in the early 1970s show various forms of restraint, either in the sparse application of oil pigment, or in the typically pale watercolours. Only occasionally do they erupt into splashy summer blooms and the heady colours of summer landscape, or into the densely handled texture of a picture such as *Red-headed Nude* (Pl. 32). With its glowing frizz of hair and dark green mat, this small painting luxuriates with the colour of oriental lacquer. The oil was elaborated from a quick drawing in coloured pencil, one among many drawings Elizabeth continued to make in the college life class, and one of several figure paintings completed at this time. Some six years later the vertical arrangement of the figure in *Red-headed Nude* has swung off-centre for the golden-haired *Girl in a Black Dress* (Pl. 31) and a precarious balance established with a strange tiger-like cat.

In her still-life oils of that decade, the artist describes herself as 'almost teetering on the brink of abstraction'. The point of reference in the real world becomes simply a starting point for a more ambitious ordering of things as she begins to achieve a synthesis in her work between real-life experience and the free flow of her imaginative ideas. *Grey Table* (Pl. 37) is typical of a group of large pictures conceived with oriental economy and refinement. Grey or white grounds are articulated by threads or patches of colour; thinned paint is worked sparingly over the canvas, wiped off or allowed to run down in fine veils.

As if to discipline these floating visions, Elizabeth experimented with grids and with bands of geometric forms—cubes and boxes—in dark browns and buffs, or in the rainbow colours of Klee as in *Still Life with Toys* (Pl. 35). Framing and containing devices, ambiguous and sometimes mysterious, have always intrigued her and account for the running theme in her painting of windows, bordered rugs and decorative frames (Pl. 36). One morning in 1976 she caught sight in the mirror of the sculpted shape of some new dining-room curtains and an endlessly inventive game began of looking and discovering pictures on the surface of the glass, of shifting her viewpoint, incorporating another object and inventing another picture. The result was a set of variations on the theme of mirrors and windows (Pl. 38).

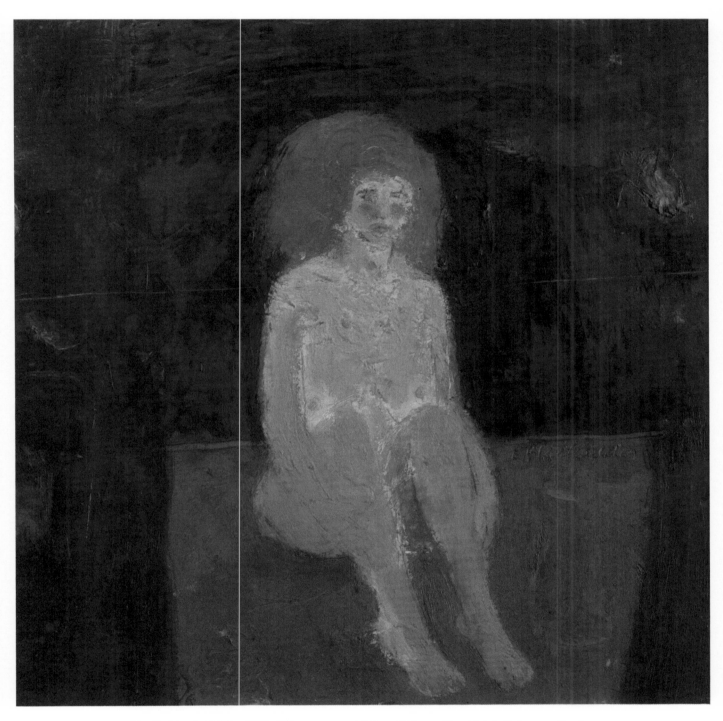

32. *Red-headed Nude*. 1971. Oil on canvas, 20.3 × 19.1 cm (8 × 7½ in). Private collection

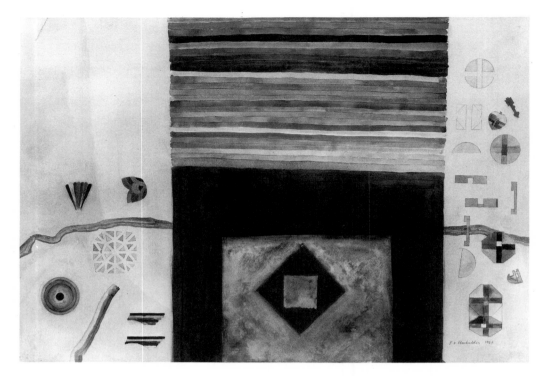

33. *Still Life with Japanese Puzzles*. 1969. Watercolour, 68.6 × 102.9 cm (27 × 40½ in).
City of Edinburgh Art Centre

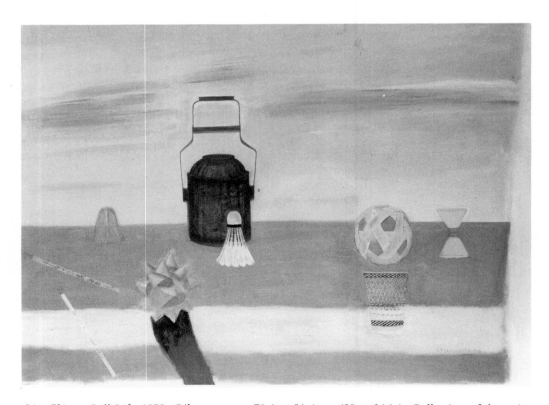

34. *Chinese Still Life*. 1978. Oil on canvas, 71.1 × 91.4 cm (28 × 36 in). Collection of the artist

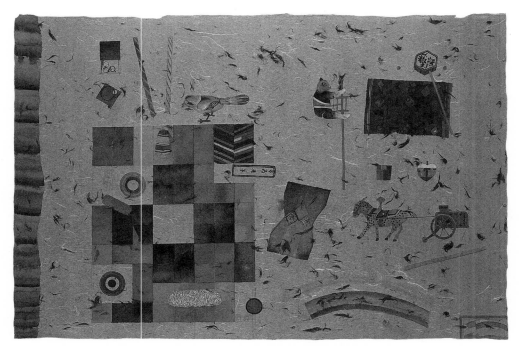

35. *Still Life with Toys.* 1978–9. Watercolour, 63.5 × 94 cm (25 × 37 in). Private collection

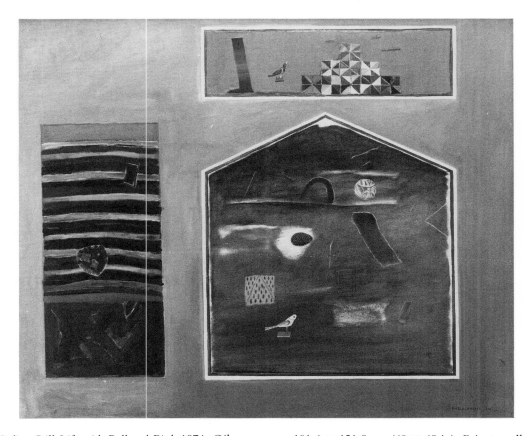

36. *Indian Still Life with Ball and Bird.* 1974. Oil on canvas, 101.6 × 121.9 cm (40 × 48 in). Private collection

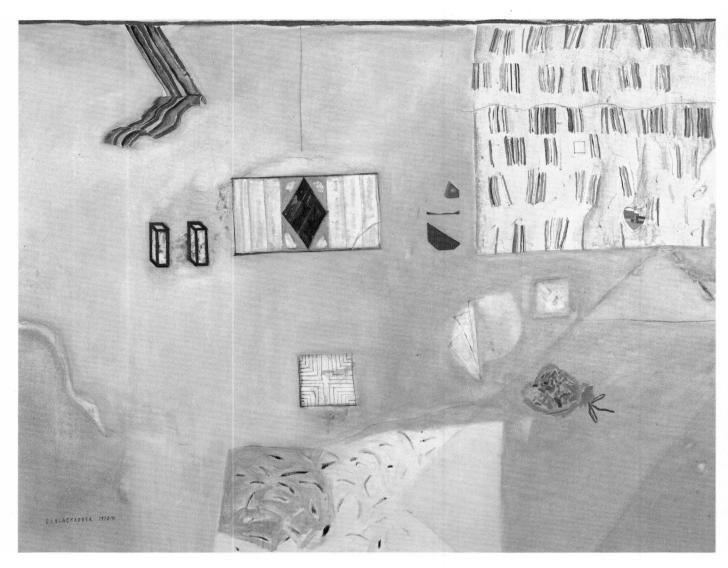

37. *Grey Table*. 1970–1. Oil on canvas, 111.8 × 142.2 cm (44 × 56 in). Private collection

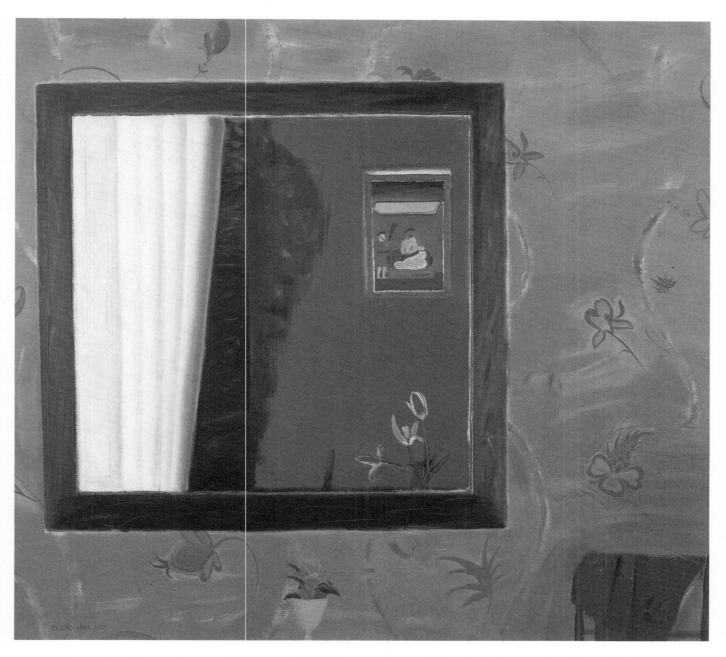

38. *Tulips and Indian Painting*. 1977. Oil on canvas, 101.6 × 111.8 cm (40 × 44 in). Heriot-Watt University, Edinburgh

Driving down through France in the late summer of 1971 Elizabeth and John found themselves crossing into Switzerland. 'We hadn't intended to go there, but when we ended up in it, we enjoyed it. The tremendous scale of the mountains put me in mind of Turner and made me go back and look at his paintings again with greater understanding.' They returned the following two years and it was this overwhelming scale that the artist tried to render in her large oil painting, *Lake Brienz* (Pl. 41). Her clear preference for a landscape composed of rocks and water was oriental in concept, but her distillation of the scene in terms of flattened forms, play of tones and rhyming patterns was entirely western. Despite its abstract language, the rosy glow of clouds over icy bright water flecked by shadows suggests a very romantic response to the grandeur of the Swiss Alps.

In 1974 Elizabeth Blackadder visited the Isle of Harris for the first time, where she made many drawings of the knuckly landscape, interrupted by passages of smooth water (Pl. 45), and of its shaggy grazing sheep. These drawings prompted a number of studio oils and watercolours that evoke the colour and structure of the land (Pl. 42). She returned to the Western Isles once more the following year, sketching distant views of Scalpay and the sheer cliffs of the Shiant Isles. The severity of the islands appealed to her, but when she submitted a dark and austere watercolour as her diploma piece to the Royal Academy on her election in 1976, it was felt to be rather too sombre for southern taste and *Still Life with Peruvian Birds* was selected instead.

Elizabeth's studio in Queen's Crescent opened onto the garden, which created a natural extension to her working environment. As the 1970s advanced, vases of flowers from the garden provided her ever more frequently with subject-matter. Tulips figure largely in her work, their brilliant sculptural shapes glowing out of a neutral black or white ground (Pl. 52).

In the early 1960s Japanese papers had become available in Edinburgh, and Elizabeth was excited by their attractive textures: 'But I found them difficult to use at first because I liked to soak paper and the Japanese paper would just disintegrate. Then gradually I found that I liked painting on it when it was quite dry, letting the colour blur on the absorbent surface.' Several years and many attempts later, she painted the beautiful watercolour *Grid Still Life with Chevronned Hanging* (Pl. 39). By then she had mastered a technique of working on these absorbent papers, controlling delicately flowing washes, as well as strong geometric and naturalistic shapes, with pigment of jewel-like intensity.

39. *Grid Still Life with Chevronned Hanging*. 1973. Watercolour, 62.2 × 99.1 cm (24½ × 39 in). Private collection

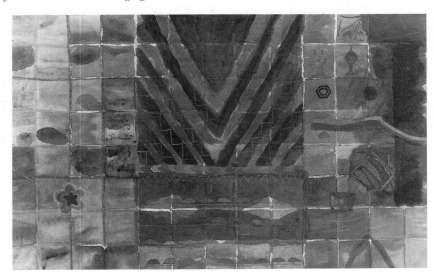

40. *Eastern Still Life*. 1980. Tapestry woven by Edinburgh Tapestry Company, 142.2 × 213.4 cm (56 × 86 in). Government Art Collection, on loan to the British Embassy, Warsaw, Poland

In 1974 she started to incorporate snipped-off flower heads as a means of introducing naturalistic imagery into her arrangements of inanimate objects. The disconnected layout opened up new possibilities. She let the random pattern of textured Japanese paper establish a surface unity and concentrated on the impeccable placing of objects to create a pictorial tension, as in her cartoon for the tapestry *Eastern Still Life* (Pl. 40).

Elizabeth's black cat was an insinuating presence in her home, but it was some years before she found a satisfying way of capturing its essential qualities without resorting to sentimentality. 'At first I thought, how can you make a drawing of a cat without it just being pretty or sweet? Then I began to look at other people who'd painted cats beautifully like Bonnard, Gwen John and Manet — the Egyptians and Japanese rendered them unsentimentally, too, of course. And I thought, it *is* possible.' And so a black cat began usurping a chair or a shawl in one or two paintings at the end of the 1960s and in the early 1970s.

The 1970s were a highly productive and successful period for Elizabeth Blackadder. She was elected an Associate of the Royal Academy in London in 1971 and an Academician of the Royal Scottish Academy in 1972. She had her first Edinburgh Festival exhibition at The Scottish Gallery in 1974 and was elected an Academician in London in 1976, the first woman to become both an R.A. and an R.A. She was also given her first exhibitions devoted to watercolour, one at the Mercury Gallery in 1969 and another in Florence in 1970, confirming her reputation as one of Britain's leading watercolourists. Elizabeth was heir to the vigorous contemporary tradition of Gillies and Maxwell not only in the quality of her watercolours, but in the sheer scale of her work.

The Houstons now felt they needed more space for painting and storage, and so in spring 1975 they moved into a handsome Victorian stone house in the south of Edinburgh. A special feature of the property was its well-established garden, which they planted with many varieties of tulip, iris and lily and which became an increasing source of enjoyment and a stimulus for paintings.

Three cats, black, tortoiseshell and Abyssinian, joined the household and Elizabeth began to record their independent and unexpected movements (Pl. 51) and their distinctive characteristics. Cats sleeping, cleaning themselves, stretching and walking are the subjects of some of her freest and most relaxed drawings, *Black Cat on its Back* (Pl. 61), *Abyssinian Cat Asleep* (Pl. 28) and *Tortoiseshell Cat Asleep* (*see* frontispiece).

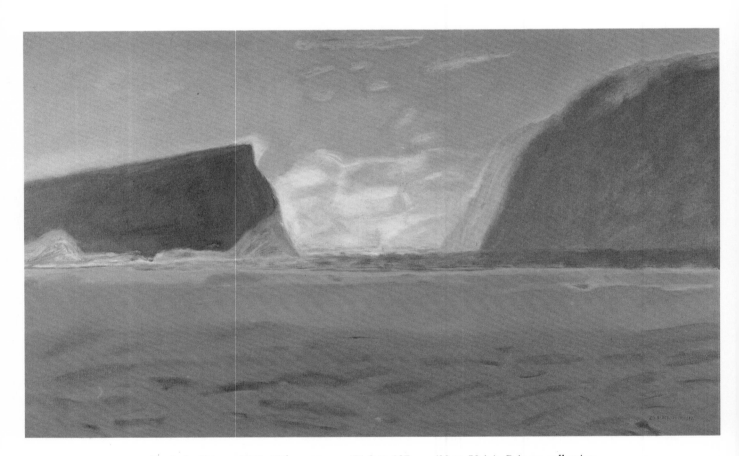

41. *Lake Brienz*. 1972. Oil on canvas, 76.2 × 127 cm (30 × 50 in). Private collection

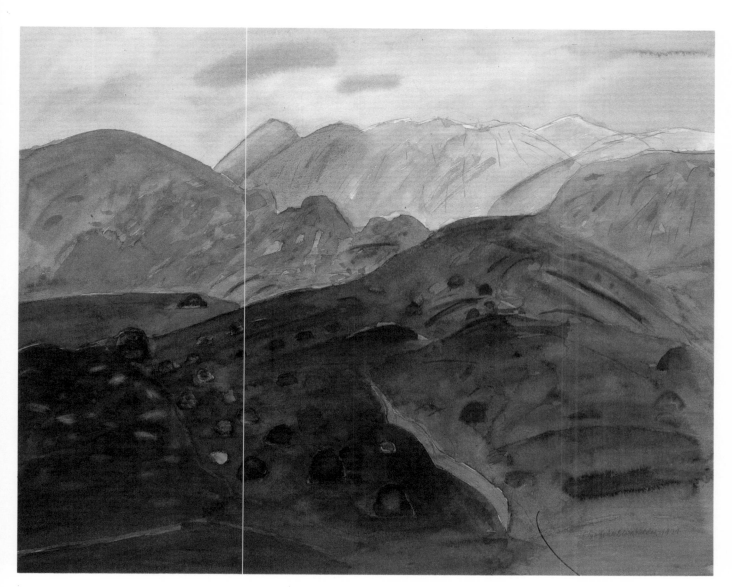

42. *Scadabay*, *Harris*. 1974. Watercolour, 68.6 × 86 cm (27 × 33¾ in). Mercury Gallery, London

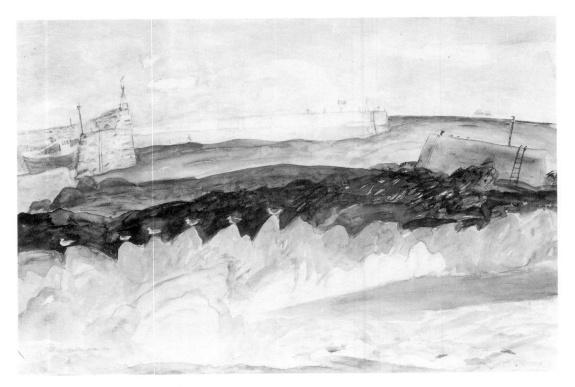

43. *St Monance Harbour, Fife*. 1978. Watercolour, 68.6 × 101.6 cm (27 × 40 in). Private collection, U.S.A.

44. *Roscoff*. 1980. Watercolour, 56.5 × 78.1 cm (22¼ × 30¾ in). Mercury Gallery, London

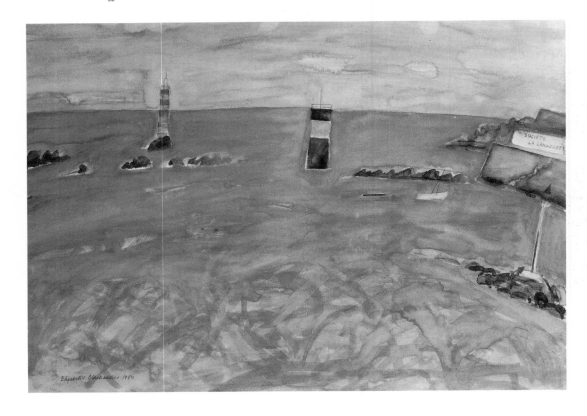

With an abundant choice of flowers, she also began to compose pure watercolour still lifes from two, three or four jugs of flowers (Pl. 50) and the ubiquitous cats (Pl. 29). The movement in these pictures suggests the 'kind of ballet' of objects that Ben Nicholson imagined when he peered through the window of a shop in Dieppe in 1932 and which he described in one of Elizabeth's favourite paintings, *Au Chat Botté*.

Elizabeth continued to make many free and vigorous pencil sketches and watercolours of the landscape. She and John took great pleasure in visiting different parts of Scotland. *St Monance Harbour, Fife* (Pl. 43) is a large watercolour using a limited palette of greys, blues and browns to highlight the analogies between the colour of the stone, the sea and the seagulls perched in formation on the wall. They also made many trips to Normandy and Brittany, where Elizabeth drew and painted the beaches, towns and landscape. *Roscoff* (Pl. 44) was painted in 1980 after their third visit to the area.

> I just like the little towns and the coast and the cliffs. The light is quite amazing, very high in key. The cliffs are of flint and chalk and the beaches are very stony, sloping steeply into the sea, which influences the colour of the water. Sometimes it's almost opaque Naples yellow in colour. Sometimes the colour is very strong, an emerald green or vivid blue. The beaches are very light in tone which makes it fairly difficult to do in watercolour because, if you add white, the effect is deadened. It's a place I could return to many times.

While in France they made a point of visiting the 'Paris/Berlin' exhibition and subsequent shows at the Centre Pompidou, recently opened in Beaubourg, Paris. Fire-eaters, jugglers, acro-

45. *Loch Collam, Harris*. 1975. Ink and pencil on paper, 39.4 × 58.4 cm (15½ × 23 in). Private collection

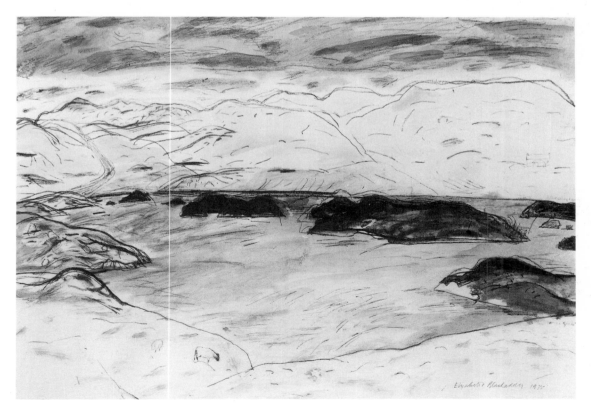

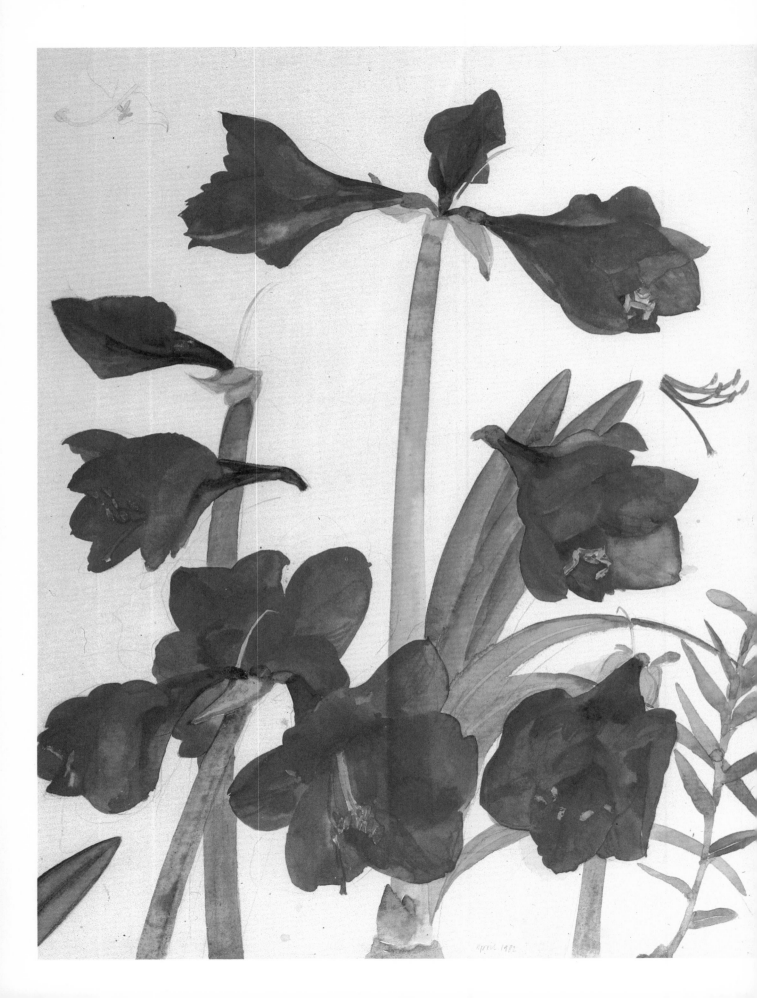

April 1982

46.  *Amaryllis and Orchids*. 1982.
Watercolour, 55.8 × 78.8 cm
(22 × 31 in). Private collection

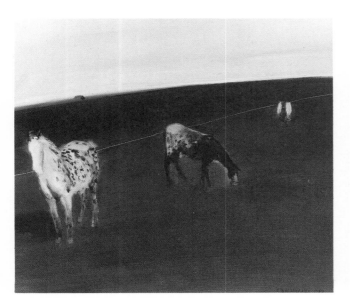

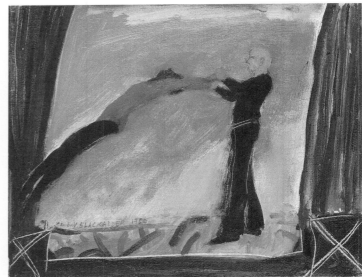

47. *Circus Horses*. 1980. Oil on canvas, 29.2 × 34.2 cm (11½ × 13½ in). Private collection

48. *Acrobats*. 1980. Oil on canvas, 18.4 × 26 cm (7¼ × 9¼ in). Private collection

bats and conjurors were active on the forecourt and this colourful sight inspired a group of small oil paintings (Pl. 48). They were based partly on the Beaubourg entertainers and partly on the combined impressions of Chinese acrobats seen on television and of a small travelling circus in northern France (Pl. 47), as well as on her memories of the fairs at Falkirk which she had loved as a child.

In 1979 Elizabeth collaborated with Dr Brinsley Burbidge of the Royal Botanic Garden in Edinburgh in organizing 'The Plant', an exhibition of contemporary Scottish flower painting and illustration. From her own work she showed a watercolour and one of the small sketchbooks that, since 1977, she had begun to fill with wild- and garden-flower studies. In a contribution to the exhibition leaflet she concluded: 'Flowers were a great inspiration to many of the last generation of Scottish painters . . . for example Robert Henderson Blyth, William Gillies, John Maxwell and Anne Redpath.'

Her own love for the subject grew steadily, stirred by her admiration for the great botanical artists of the past, in particular Ferdinand Bauer and George Dionysus Ehret: 'Looking at the way others had observed plants, I began to look at the real thing with a fresh eye.' These artists provided inspiration for the more exacting task of making her first botanical study in 1979 of an amaryllis and crown imperial (Pl. 62) which she had been growing at home. The amaryllis became a favourite plant, which she never tires of painting (Pl. 46).

As she became increasingly involved with watercolour painting, she began to relate her work in this medium more closely with her growing interest in Far Eastern art. Paintings such as *The Black Fish* (Pl. 53) are mysteriously oriental in their use of space. Layers and depths are created by applying dry paint over wet wash and by exploiting the ornamental effect of gold paint. The use of gold in early Italian painting, Byzantine illuminations and in Catalan and Romanesque painting had long appealed to her for the way it detached individual forms against a sumptuous background and, simultaneously, unified the composition. She began to explore its shimmering texture in another medium, lithography.

In the late 1970s, Gillian Raffles of the Mercury Gallery commissioned Elizabeth to make two lithographs: *Still Life with Indian Toy* (Pl. 54), in four colours, black, red, buff and 'gold', and *Black Cat* (1980), in black and orange. Both were printed in limited editions at Peacock Printmakers in Aberdeen where she worked with two highly skilled printers, Arthur Watson and Stewart Cordiner. *Still Life with Indian Toy* involved Cordiner in two complex processes: laminating a Japanese paper onto Arches paper (*chine collé*); and creating 'gold' passages by dusting powder onto wash while it was still wet. The sensitivity of this lithograph with its delicate washes and nuances of tone makes it one of her most accomplished and satisfying still lifes, and it demonstrates how much more sympathetic the stone is to her subtleties and softnesses of colour than the harsher processes of screen printing which were employed in making *Still Life with Wooden Toys* (1984).

Sometime in 1980 Elizabeth began making experiments with small pieces of white gold and gold leaf, occasionally at first and then more consistently. As she became accustomed to its tricky application, she turned the movement introduced by broken surfaces and torn edges to advantage. In a busy composition, *Still Life with Camellias* (Pl. 57), a large area of gold leaf has been applied over a red wash and then further enhanced by decorating the surface with a design in red paint.

Much of Elizabeth's time at the start of the 1980s was taken up with preparations for the Edinburgh opening in July 1981 of her retrospective exhibition, which subsequently toured to Sheffield, Aberdeen, Cardiff, Liverpool and London. It was the first in a projected series organized by the Scottish Arts Council, with which they hoped to promote the national reputations of artists living and working north of the border, and its curator, William Packer, introduced the catalogue with the words: 'It is extraordinary that Elizabeth Blackadder is not by now rather more celebrated than she is.' And pointing to the difficulties for a Scottish artist remaining in Scotland to establish a national reputation, he went on: 'Elizabeth Blackadder is well enough known, in Scotland very well known; and yet the Arts Council of Great Britain, for example, owns no work of hers at all, the British Council nothing, the Tate very little and nothing recent.' He also remarked that 'metropolitan parochialism is such that London remains the place where the national name is made.' In the Queen's 1982 Birthday Honours Elizabeth was awarded the O.B.E. and it was perhaps an irony that this honour should have coincided with the London showing of her retrospective at the Royal Academy.

49. *Figure.* 1980. Pencil on paper, 20.3 × 27.9 cm (8 × 11 in). Private collection

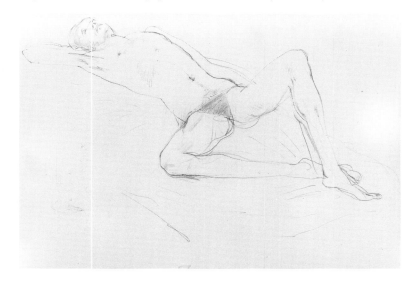

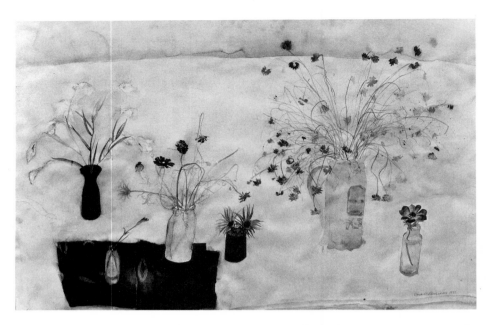

50. *First Spring Anemones*. 1977. Watercolour, 68.8 × 102 cm (27¼ × 40¼ in). Hove Museum and Art Gallery

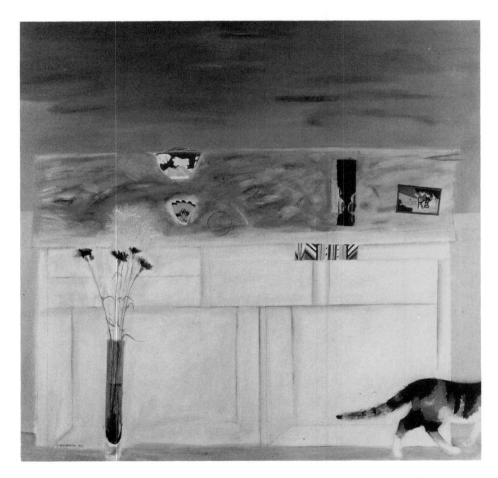

51. *Coco and Cupboard*. 1979. Oil on canvas, 122 × 122 cm (48 × 48 in). Private collection

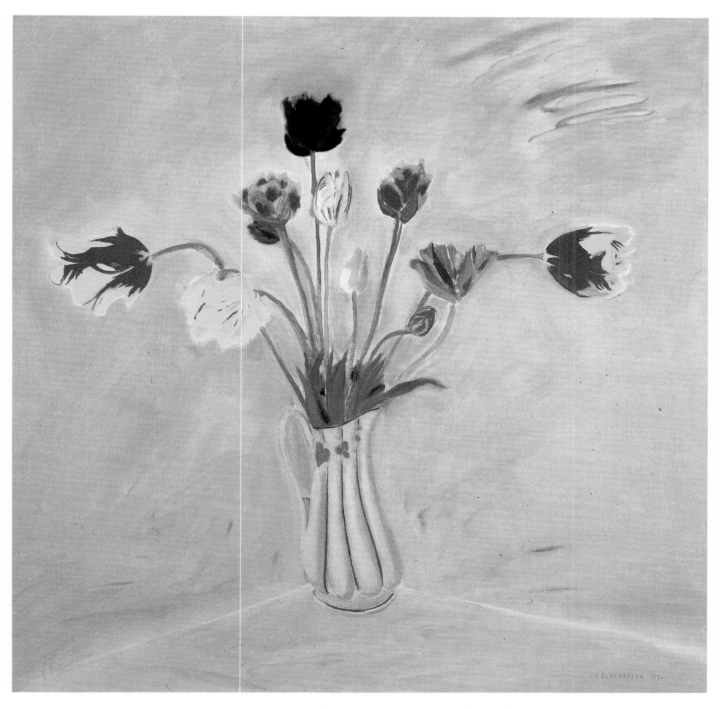

52. *Tulips on a White Ground*. 1974. Oil on canvas, 90.2 × 90.2 cm (35½ × 35½ in). Private collection

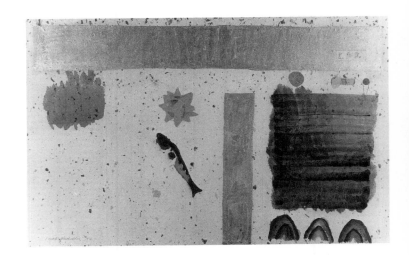

53. *The Black Fish*. 1978. Watercolour, 59.5 × 90 cm (23½ × 35½ in). Bolton Museum and Art Gallery

54. *Still Life with Indian Toy*. 1982. Lithograph on Japanese paper on Arches, 46 × 58 cm (18 × 23 in). Published by Mercury Gallery, London; printed at Peacock Printmakers, Aberdeen

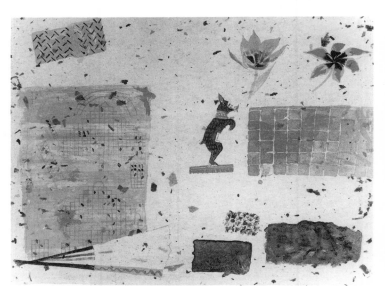

55. (below) *Still Life with Cards and Inro*. 1985. Watercolour, 34.2 × 120 cm (13½ × 47½ in). Private collection

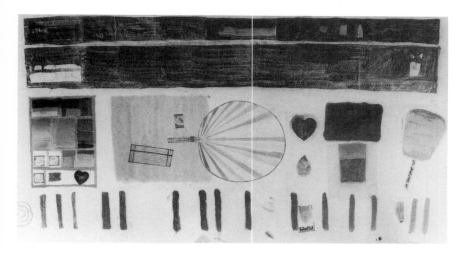

56. *Gold and White Still Life*. 1980.
Watercolour, 68.6 × 132 cm (27 × 52 in).
Private collection

57. *Still Life with Camellias*. 1984.
Watercolour, 58.4 × 91.4 cm (23 × 36 in).
Atkinson Art Gallery, Southport

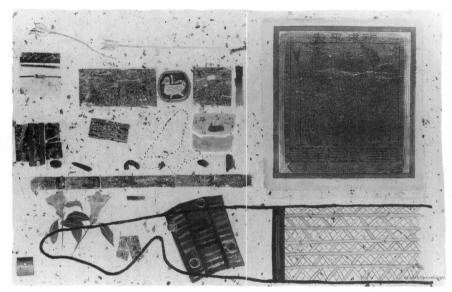
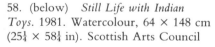

58. (below) *Still Life with Indian
Toys*. 1981. Watercolour, 64 × 148 cm
(25¼ × 58¼ in). Scottish Arts Council

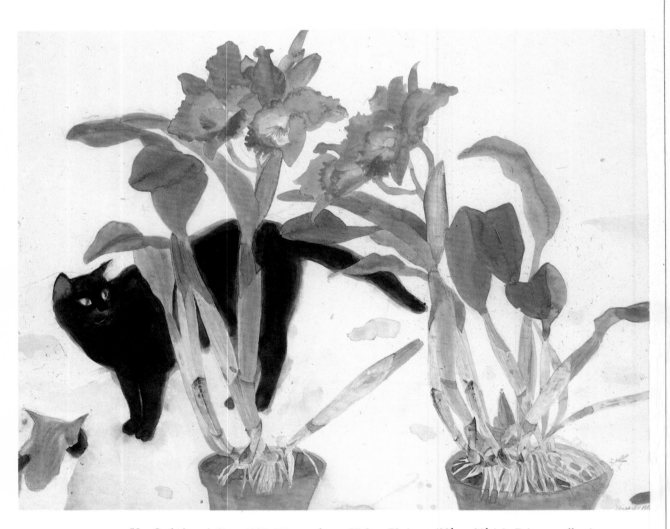

59.  *Orchids and Cats*. 1986. Watercolour, 57.2 × 79.4 cm (22¼ × 31¼ in). Private collection

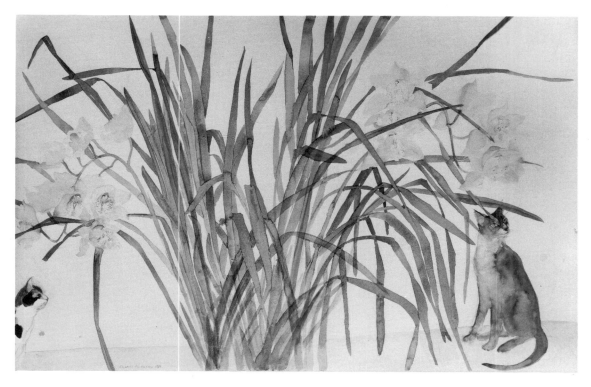

60. *Cats and Orchids*. 1984. Watercolour, 80 × 120.8 cm (31½ × 47½ in). Private collection

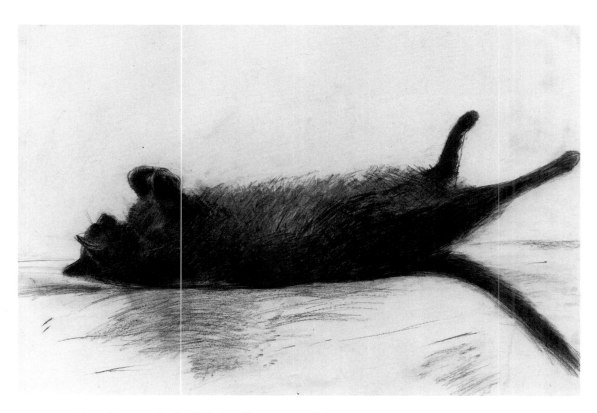

61. *Black Cat on its Back*. 1975. Pencil on paper, 43.2 × 61 cm (17 × 24 in). Private collection

Some of the latest works shown in her exhibition reflected her more focused interest Japanese art. This was further stimulated by another event at the Academy, the 'Great Jap Exhibition: Art of the Edo Period 1600–1868'. Elizabeth visited the first part of the exhibition 1981 and later expressed her sympathies: 'I love some of the Chinese things that I've seen museums, especially the ceramics and paintings, but they have never made such an impact on me Japanese art. Some of the objects appeal to me particularly—netsuke, lacquered boxes, cerami calligraphy and scroll paintings.' The form of the scroll had fascinated her since she began looki at Byzantine scrolls as a student and in 1980 she began to emulate it in a painting fifty-two inch long entitled *Gold and White Still Life* (Pl. 56). The scroll's shifting perspectives and viewpoints essential emphasis on pictorial space rather than time, its narrative and decorative effects and its various devices to create movement, moments of tension and relaxation all suggested that, in theory, the horizontal form would lend itself to limitless extension.

Elizabeth's manner of working very wetly in watercolour required a flat surface. At first she worked on the floor and then, from 1979, on a large formica-topped table, which was ideal for spreading out her painting materials, objects, vases of flowers and, generally, for 'having things around' her. Her collection was now so considerable that she began to hang larger, flatter objects, such as fans, on the wall so that she could observe their shapes more readily (Pl. 78).

*Still Life with Cards and Inro* (Pl. 55) shows Elizabeth composing left to right across the surface of a long piece of paper rather like a musical score. While working she often listens to music, both to Western classics and, since she visited Japan, to Japanese music, and the shape of the sounds may unconsciously suggest a spatial configuration. Other artists are aware of this analogy, notably

62. *Amaryllis and Crown Imperial*. 1979. Watercolour, 57.2 × 78.7 cm (22½ × 31 in). John Houston

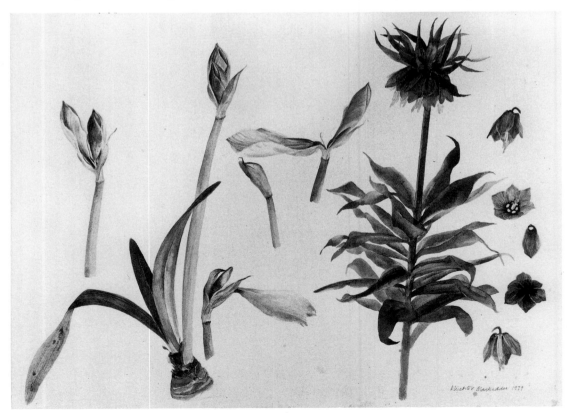

66

Carel Weight, who wrote in 1981: 'I feel that the painting of Elizabeth Blackadder comes closer to music than that of any other painter I know, with the possible exception of Paul Klee. She uses accents of colour with the sureness of a composer when he makes a single note on the triangle tell above the full volume of orchestral sound. She relies on her instinct and she is seldom wrong.'

As Elizabeth developed her ideas for using the form of the paper scroll, she found she was able to balance even more elaborate compositions and, by 1982, she was using paper almost five feet long. *Still Life with Hearts and Flute* (Pl. 80) and *Japanese Still Life with Irises* (Pl. 81) are not pendants, but they create a delightfully contrasting pair. The one is austerely painted on white handmade paper with a restrained horizontal orientation; the other is altogether more active and ornamental, with its decorative wood flecks, gold leaf and vertical rhythms.

The lithe and apparently intricate form of the iris appears in many of Elizabeth's still lifes. It is a favourite flower and in 1979 she began to document in small sketchbooks each variety as it appeared in the garden (Pl. 67). She has painted many large iris compositions too (Pls. 1, 64, 66, 68). In 1987 the Dovecot Studios in Edinburgh successfully translated one of these iris paintings into a tapestry worked on a very much larger scale.

Increasingly, she played off the colour of her cats against the shapes and colours of the flowers: the compact bodies of the three cats against the vertical stalks of red-hot pokers in *Three Cats and Three Kniphofia* (*see* Pl. 95); the patterned fur of the tortoiseshell cat against the flamboyant colours of day lilies, poppies and gladioli, or the fine nuances of auratum lilies. The sharp note introduced by the black cat acts as a bold foil to intense pink flowers (Pl. 59), while the shadowy Abyssinian cat in *Cats and Orchids* (Pl. 60) seems to identify herself with the plants.

63. *Aloe.* 1985. Watercolour, 55.8 × 78.8 cm (22 × 31 in). Collection of the artist

64. *Iris Heads*. 1983–4. Watercolour, 45.8 × 79.4 cm (18 × 31¼ in). Private collection

65. (right)  *Lilies*. 1987. Watercolour, 102.8 × 69.8 cm (40½ × 27½ in). Collection of the artist

Elizabeth Blackadder 1985

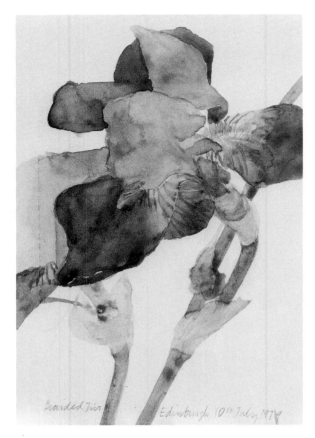

66. *Irises.* 1987. Watercolour, 102.9 × 69.9 cm (40½ × 27½ in). Private collection

67. *Page from the Iris Sketchbook.* 1979. Watercolour, each page 15.2 × 10.2 cm (6 × 4 in). Collection of the artist

One of the reasons why cats slip so naturally into Elizabeth's flower paintings is that they complement the supple and graceful movements of her preferred flowers. Elizabeth has looked closely at the more involved forms of exotic species: the delicacy of auratum lilies (Pl. 65) and of gladioli, as well as the gorgeously coloured and bizarrely ornamental varieties of hothouse orchid. She has enormous sympathy with living forms and she appears to see each flower afresh every time she paints it. 'Every flower has its own texture and character. The reflective sheen of tulips, the fleshiness of lilies and orchids and the crumpled tissue paper quality of poppies. More than this, you have to understand how a plant works and to know a little bit more about its structure than you actually draw.' The most complex of all floral structures is the orchid and in the watercolour *Orchid Brassolaeliocattleya 'June Moore'* (Pl. 71) Elizabeth made her first botanical study of a purplish, speckled hybrid variety. She has not only analysed it with great accuracy, studying it first under a magnifying glass, but she has also rendered the grotesque behaviour of its ruffled petals and trumpet-shaped *labellum*, or lip.

Elizabeth's visits to the Royal Botanic Garden in Edinburgh where, from 1981, she helped run a course in botanical illustration, gave her free access to rare plants. But extreme accuracy of recording interested her less than the desire to give life to the plant by whatever means were at her disposal. To some people the smudges in her watercolours appear 'messy', but to others, including botanists, her realization of a fully recognizable three-dimensional plant communicates itself with great immediacy.

If Elizabeth's accuracy of observation became more acute, her personal vision and her ability to capture the essence of plants and to transfer it fluently and very beautifully to the page remained unaltered. Her sense of spacing seems infallible whether she is opening up the page with a spare oriental design of showy *Poppies and Begonias* (Pl. 70), or crowding it with ornamental parrot tulips in *Texas Flame* (Pl. 74). This flamboyant composition has also been translated into tapestry using cotton to render its glossy petals.

Like the Dutch masters Elizabeth has an eye for the fortuitous contribution of fallen petals to her designs. Usually she makes the occurrence look entirely natural, but in *Still Life, Fallen Tulips* (Pl. 72) she has contrived a small still life from the petals that have dropped from the stem.

> I quite liked flowers when they had faded or withered. I'd bring them in from the garden and then find that I couldn't paint them. They looked too *stiff* in a way. A day or so later they'd taken on their own kind of movement and they looked much more interesting and I'd paint them. Sometimes I'd leave them for days or weeks until they were withered and dead and became something completely different.

To her surprise a Swedish botanist bought one of the paintings, a measure of a fellow naturalist's objective appreciation of plant life in all its stages.

In a painting done in 1983, *White Anemones* (Pl. 75), the flowers have been allowed to bend and twist into bizarre attitudes, to shed their petals and expose their green and black knobs. The watercolour is one of Elizabeth's most oriental looking, and the effect of these spring flowers set against a white background is of a delicacy and purity that matches their gracefulness. Elizabeth retains the translucency of their petals in an intricate design made up of pots of coloured anemones and single suspended stems, *Anemones* (Pl. 73). The way she has observed the idiosyncratic behaviour of the flowers as they pass from buds to full bloom challenges the conventional beauty of formal arrangements.

68. *Irises.* 1986. Watercolour (study for tapestry woven by Edinburgh Tapestry Company), 68.6 × 101.6 cm (27 × 40 in). Collection of the artist

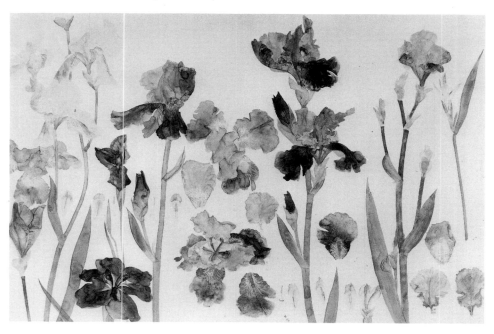

69. *Still Life, Kurashiki*. 1986. Watercolour, 61.5 × 159.3 cm (24¼ × 62¾ in). Private collection

Just as Elizabeth's Eastern still lifes recorded one aspect of changing consumer taste so her still lifes of fruit and vegetables charted another aspect of it. She had already painted gourds and the visually more complex forms of artichokes. Then, in the 1980s, she started to include the exotic fruits that had begun to appear regularly in supermarkets, such as kumquats, lychees, passion fruit, nectarines, mangoes, kiwi fruit, fresh dates, papayas, plum tomatoes and, more recently, the appropriately named star fruit in *Still Life, Star Fruit and Fan* (Pl. 82). Handling them and looking at their strange shrivelled, hairy or bloomed skins as well as their luscious seeded interiors and pitted stones, Elizabeth saw them as a subject for her painting. These imported fruits suggested a contemporary equivalent to her of seventeenth- and eighteenth-century Dutch paintings of tables heaped with fruit and flowers.

Elizabeth was steadily increasing the scale of her watercolours and in 1983 she embarked on a very large still life combining many of the small children's toys she had collected from all over the world (Pl. 83). It was completed the following year and included many Indian toys of a simple decorative shape that had first enticed her in 1964. *Still Life with Children's Toys* is a delightful painting that employs the visual pleasure and ingenuity of folk art as subject-matter to produce a most accomplished piece of design.

Indian painting continued to intrigue her, particularly Rajput painting with its brilliant colour, its meticulous and exquisite draughtsmanship and its decorative combination of realism and lyricism, the ornamental and the natural. Her paintings *Still Life, Sandalwood Fan* (Pl. 76) and *Still Life with Indian Belt* (Pl. 77) reflect this influence. In *Still Life with Rembrandt Tulip* (Pl. 79) the petals of the tulip and a pink camellia are orchestrated with a scattering of small decorative objects, bounded by the strong lines of a black belt.

70. *Poppies and Begonias*. 1986. Watercolour, 76.8 × 57 cm (30¼ × 22½ in). Private collection

71. *Orchid Brassolaeliocattleya 'June Moore'*. 1980. Watercolour, 70 × 70 cm (27½ × 27½ in). Private collection

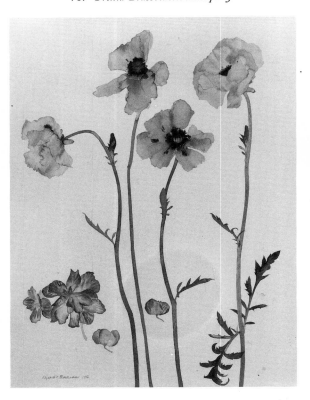

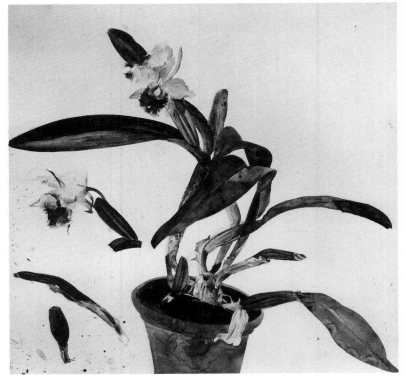

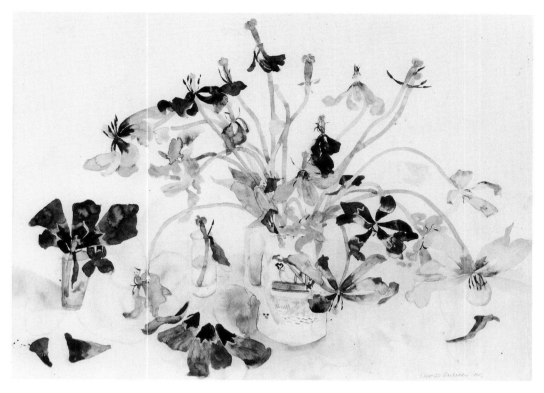

72. *Still Life, Fallen Tulips.* 1982. Watercolour, 57.2 × 78.8 cm (22¼ × 31 in). Private collection

73. *Anemones.* 1984. Watercolour, 57.2 × 78.8 cm (22¼ × 31 in). Private collection

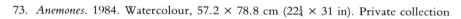

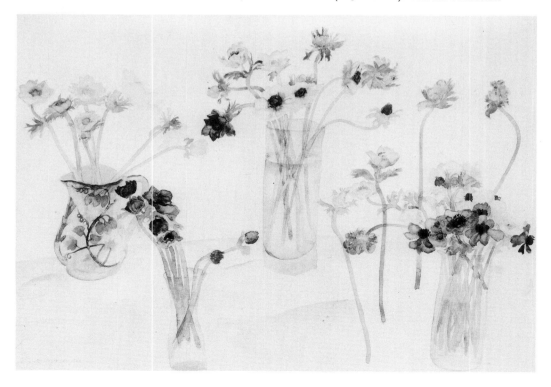

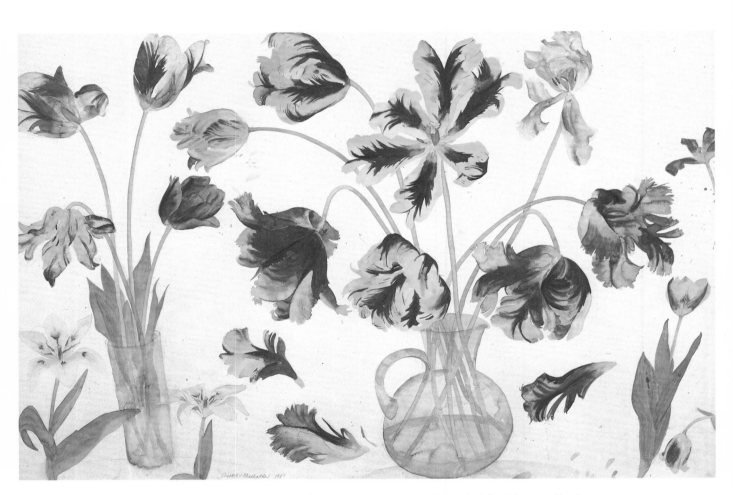

74. *Texas Flame*. 1986. Watercolour, 68.6 × 104.2 cm (27 × 41 in). Private collection

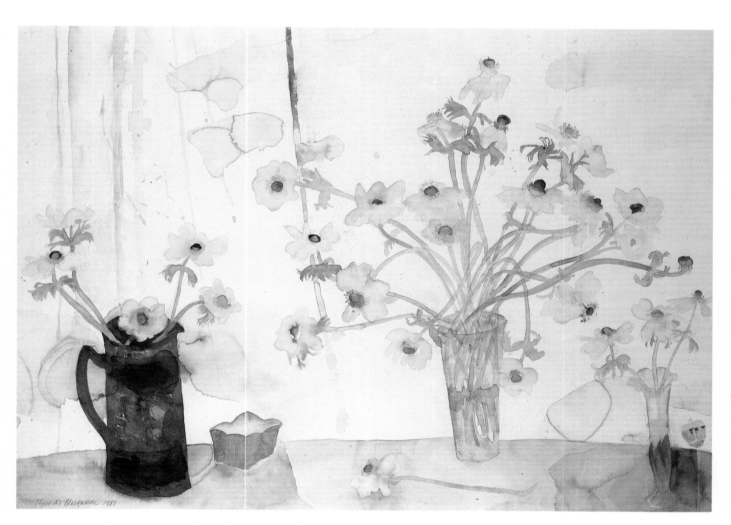

75. *White Anemones*. 1983. Watercolour, 55.8 × 78.8 cm (22 × 31 in). The Marchioness of Dufferin and Ava

76. *Still Life, Sandalwood Fan*. 1984. Watercolour, 62.5 × 98.8 cm (24½ × 38½ in). Huddersfield Art Gallery

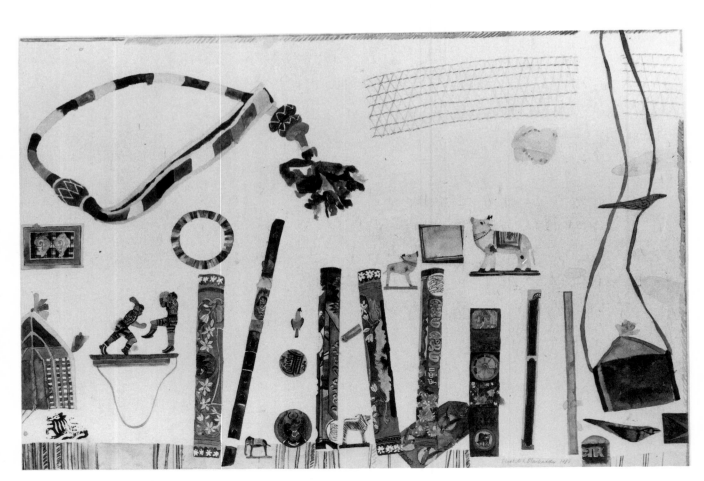

77. *Still Life with Indian Belt*. 1985. Watercolour, 59.7 × 94 cm (23½ × 37 in). Private collection

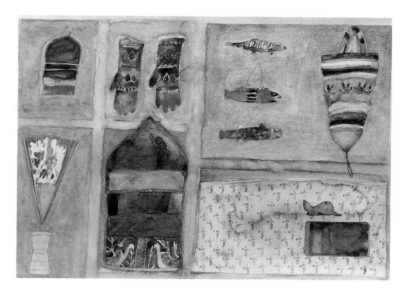

78. *Still Life with Peruvian Hat*. 1979. Watercolour, 55.9 × 76.2 cm (22 × 30 in). Mercury Gallery, London

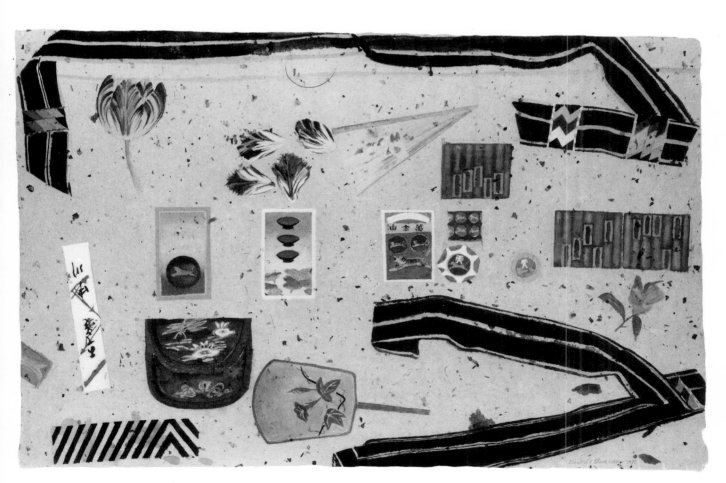

79. *Still Life with Rembrandt Tulip*. 1985. Watercolour, 61 × 91.4 cm (24 × 36 in). Private collection

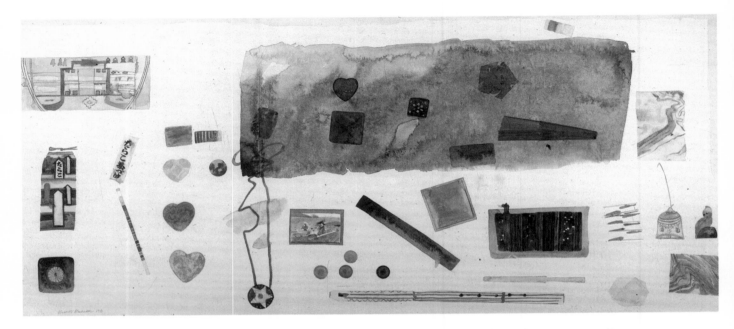

80. *Still Life with Hearts and Flute*. 1980. Watercolour, 64.8 × 146 cm (25½ × 57½ in). Private collection

81. *Japanese Still Life with Irises*. 1980. Watercolour, 59.6 × 146 cm (23½ × 57½ in). Private collection

In 1985, when Elizabeth was asked to do some etching at the Glasgow Print Studio, she revived a technique she had not practised since her student days. Her interest in botanical drawing lent itself to the medium and she drew *Hibiscus and Cats*. It was her first print made *à la poupée* with printer John Mackechnie in order to render the grace and softness of these crinkly petalled flowers. In 1986 Elizabeth returned to Glasgow where she did a number of etchings of still life and of plants such as *Orchid* (*see* p. 4). Printmaking went hand in hand with her paintings of plants from the hothouses of the Botanic Garden, from her own greenhouse and from plants lent to her by her friends. Among them were studies of a water-lily leaf and a banana plant. *Aloe* (Pl. 63) is a very beautiful treatment of the plant. The lively way Elizabeth has exploded the plant in all its details and at various stages of blooming was an expedient solution as well as conveying the vigorous character of the aloe. She has made the most of the dramatic shapes of spiny leaves and clusters of pinky red flowers which turn bright yellow as they wither.

A landmark in Elizabeth's career was her first trip to Japan in the Easter vacation of 1985. The three-week visit, which included Tokyo, Kyoto, Sendai and Kurashiki, was as exciting as it was bewildering. The clash of opposites in the country was a shock in itself: the serenity of the temple gardens came as an astonishing contrast to the harsh modernity of the department stores and building complexes. In Tokyo John and Elizabeth enjoyed the collections of paintings, sculpture and calligraphy, but decided to spend most of their time in Kyoto. After the rush of the city, the temples and Zen gardens featuring stone, water and raked sand brought welcome peace and here, too, Elizabeth admired the typical displays of screens decorated with plants, flowers and gold lacquer.

On shopping expeditions she bought some intriguing new items that subsequently found their way into still lifes titled with Japanese place names. *Still Life, Kyoto* (*see* title page), painted on brownish Japanese paper, takes its inspiration from the boldly decorative shop signs, from tools, utensils and ornamental fragments associated with the artist's impressions and feelings about the place. The idea for *Still Life, Kurashiki* (Pl. 69), unusual in its use of white, derives from the simplicity and formality of the traditional Japanese table setting and is a reminder of one of the most cogent sources of her still lifes, the table scenes in Byzantine and early Italian painting. Gold, red, green and black lend this composition an air of joyful celebration.

In 1985 Elizabeth was commissioned to design two tapestries for the new international corporate headquarters of Reckitt and Colman at Hogarth Roundabout in London (Pls. 84a, b). The clients stipulated that the design should be 'relevant', enhance their activities and represent something of the range of their household, food and wine, pharmaceutical and fine-art products. The resulting watercolours on handmade paper use the long narrow form of her still lifes. Elizabeth combines many of the firm's well-known goods with her own imagery in a nicely calculated balance of the natural and the manmade. The Colman's mustard tin is the most readily identifiable label, many of the others being hinted at or referred to by their logos: the initials of Winsor and Newton, the sunburst from Sunny Jim firelighters, 'OK' from the sauce bottles, the bird from Robin Starch products and other more obscure references and symbols. The tapestries have discrete designs but they were planned to hang together side by side. Their harmonious colour scheme runs from left to right, through warm yellows and reds to green and then through cool blues to mauve.

The following year in October John and Elizabeth made their second visit to Japan via Hong Kong. The trip may not have had the impact of their first visit, but they were better prepared to plan a variety of excursions, as well as to return to places they had already visited 'to look at them again, and perhaps to see more in them'. They revisited Tokyo and Kyoto, where they made a

82. *Still Life, Star Fruit and Fan.* 1985. Watercolour, 59.8 × 98.4 cm (23½ × 38¾ in). Private collection

83. *Still Life with Children's Toys*. 1983–4. Watercolour, 95 × 126 cm (37½ × 49½ in). Collection of the National Museum of Women in the Arts, Washington

84a. *Reckitt and Colman Tapestry* (left panel). 1985–6. Woven by Edinburgh Tapestry Company, each panel 116.8 × 302.3 cm (46 × 119 in). Collection Reckitt and Colman, London

point of staying in two of the most famous Japanese inns, the Tawaraya and the Hiiragiya Ryokan. *Still Life, Hiiragiya* (Pl. 89) is a strong, decorative design, drawing on a very personal recollection of Elizabeth's previous visit in 1985. The juxtaposition of black and silver leaf, the small holly leaf and colourful trellis pattern assert a mood that is both rich and festive. By contrast, the exquisite and less hermetic *Kyoto Still Life with Irises* (Pl. 85), with its small porcelain dishes, ornamental Japanese paint brushes and iris heads evokes quiet and peaceful memories.

Two of the monastic temples John and Elizabeth wanted to visit in Kyoto were only accessible to worshippers and, as such, they were expected to complete ritual exercises in Japanese script at the beginning of the traditional Zen Buddhist service. Being foreigners and not understanding the language, they were let off this hard task lightly, but the idea of using calligraphic marks suggestive of script interested Elizabeth and prompted two watercolour still lifes on oracular themes (Pl. 86). The titles of these paintings refer to the wise prophecies that could be bought at Shinto pilgrim shrines.

The shrines, beautifully set in woodland, are a famous feature of Ise on Shima Peninsula and of Nikko in the north of Japan, and John and Elizabeth made special expeditions to visit some of them. The experience at Nikko was unexpected: 'There wasn't the same austerity we'd come to expect of holy places. The decoration was very colourful, almost gaudy, with a lot of gold leaf and pattern.' The resulting watercolour, *Still Life, Nikko* (Pl. 90), is imbued with the drama and excitement of the occasion. It uses a memorable device to evoke a composite image of the contrasting aesthetic experiences: a formal architectural grid superimposed on a swirling organic form suggesting the movement of water and the red autumn colouring.

Although Elizabeth finds much to intrigue the artist's eye in Japan, she has never attempted to imitate a subject-matter and aesthetic traditional to the orient. The images that appear and often reappear in her work are purely personal in their symbolic treatment. Yet, in purpose, their use is reminiscent of the 'eight precious objects' that are traditionally found depicted on Chinese porcelain and embroideries. Known also as 'treasures' or 'ancient things', their number could in

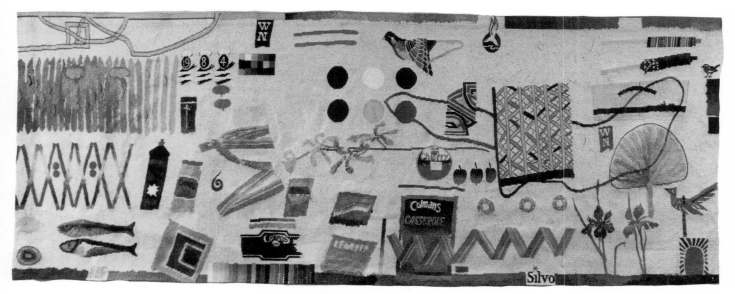

84b.  *Reckitt and Colman tapestry* (right panel)

fact vary from four, depicting the four fine arts of music, calligraphy, games of amusement and painting, to one hundred objects of many different kinds, including animals and flowers. Originally of Buddhist and Taoist inspiration, these emblems came to be applied as decorative motifs in a purely random way, but as 'charms' they retained their magical aura.

Elizabeth's Japanese still lifes, always deeply felt and mysterious, take on a sense of almost mystical communion with her subject-matter. They may be inspired by ancient garden art or by the decorative aspects of everyday life, by the beautifully packaged picnics, table settings and the presentation of food and gifts, and even by the window displays of plastic food, but like the three-line Japanese poem, the *haiku*, her pictures are suggestive of her experiences rather than explicit. Recently she has expressed her response in this way:

> Whenever I find something that is particularly sympathetic I try and incorporate it. I don't feel that I could explain the objects in any way, because I don't wholly understand the feeling of mystery surrounding them. Japan has meant more to me since my second visit. I've read and enjoyed *Cranes at Dusk* by Mitsubara and Ishiguro's *An Artist of the Floating World*. What I find interesting is that Zen is not so different to the spontaneous, not always rational way creative people—painters —work. It may be the attraction Japan has had for a lot of artists in this century. But it is difficult to understand the dichotomy in Japanese civilization. The perfection of the ancient gardens and some of the temples, as well as some very fine modern architecture, contrasts with another side—the sprawling, ugly industrial developments.

Those tensions and harmonies are acknowledged in Elizabeth's recent still lifes, which are the most original and remarkable aspects of her entire oeuvre. The genre of still life is an ancient and familiar one in which artists continue to express their pleasure in inanimate things. Elizabeth has

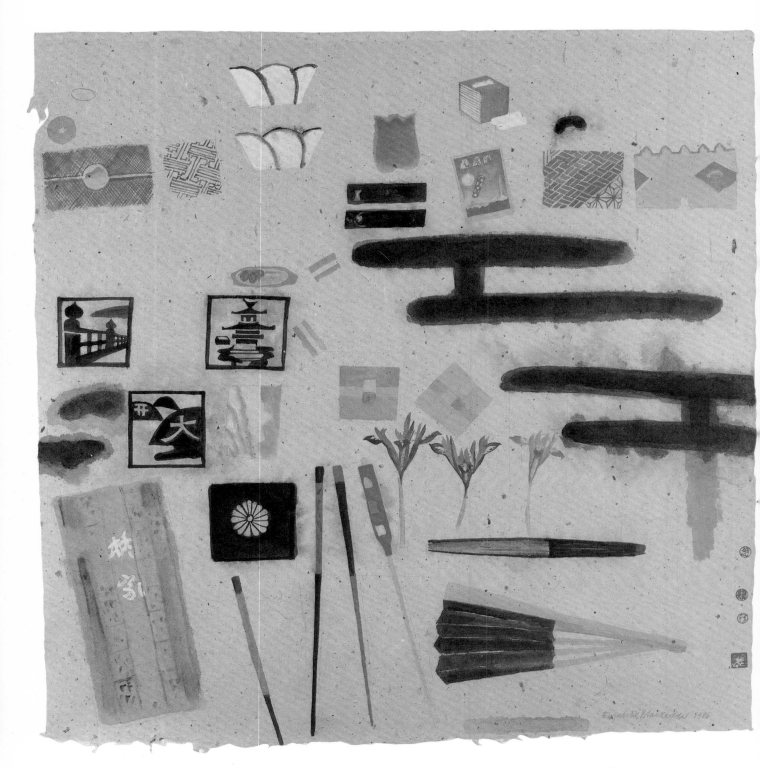

85. *Kyoto Still Life with Irises*. 1986. Watercolour, 63.5 × 61 cm (25 × 24 in). Private collection

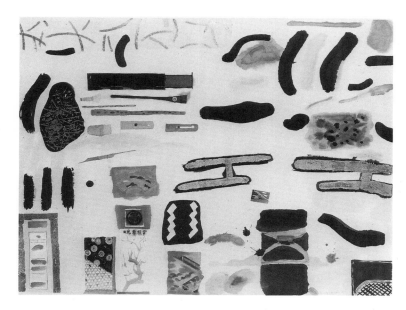

86. *Still Life with Written Oracle I.* 1987. Watercolour, 96.5 × 127 cm (38 × 50 in). Collection of the artist

found the imaginative possibilities of a limited subject-matter particularly satisfying to work with. Drawing on a long tradition of formal means, she has created a new and very contemporary way of presenting her ideas that extends the genre beyond decorative composition into an idiosyncratic pictography. Like the scroll itself, her inventiveness as it unfolds continues to surprise and beguile.

# Portraits by the Artist

This book started with a group of Elizabeth Blackadder's self-portraits by way of offering the reader an insight into her feelings and interests. It seems fitting to end it with two portraits by her of other people in which she, in her turn, tries to encapsulate what *they* are about. At the time of writing, the portraits are among her most recent work and the first paintings she has executed in the medium of oil since 1982. They are not the first portraits she has done, but they are the first, discounting the self-portraits, since her student days. Portraiture has never been central to her concerns as an artist and the figure studies she continued to make until the 1980s were done with different intentions (Pl. 49). The attainment of a likeness was incidental to the modern artist's preoccupation with picture making and to her own unwavering desire to catch a subject's essence. Her talent for investing her pictures, even of inanimate and static forms, with energy and life makes her an ideal candidate for portraiture.

As part of a policy of commissioning portraits of distinguished Scots from artists who do not usually undertake such work, the Scottish National Portrait Gallery invited Elizabeth Blackadder in 1987 to paint a portrait of the prize-winning children's writer, Mollie Hunter. Elizabeth visited

Mollie Hunter's home in the north of Scotland to make sketches and drawings of her sitter in her study. The books and objects all received her attention, including some amusing paperweights given to Mollie Hunter by her grandchildren. During the visits their conversation turned frequently to Scottish history, for many of Mollie Hunter's books have an historical core. Elizabeth portrays her, not writing, but looking meditatively out of the window, across to the distant, unseen hills, a source of so much of the legend and fantasy in her stories. Anyone who has read those stories, particularly her autobiographical book, *Sound of Chariots*, will recognize the strength of their author's character in the firmly drawn face (Pl. 87).

The same strength glows from a much older face, now a network of lines and creases and, indeed, from the whole body of *Naomi Mitchison* (Pl. 88). In the course of two sittings Elizabeth made several drawings in which she tried to catch the animation in Naomi Mitchison's face and the extraordinary mobility of her mouth.

It would be quite out of character for Elizabeth Blackadder to attempt to do more than present her sitters for our contemplation. Yet the warmth and humanity with which she has perceived them, suggests that the intensity of her vision goes beyond disinterested observation. Their sympathetic and imaginative portrayal intimates a tacit understanding of certain shared aims, not least a conscientious attitude to hard work and a steely determination to keep on working.

Elizabeth's decision to take early retirement from the College of Art in the summer of 1986 offered new scope to that resolve. The move came after some twenty years' dedicated teaching, since 1982 under the leadership of her friend, David Michie, who had succeeded Sir Robin Philipson as head of the School of Drawing and Painting. During those twenty years hundreds of students have passed through her classes and taken their diplomas under her tuition. The word 'tuition' may convey a false impression. Elizabeth has always believed sincerely in the discipline of the college's teaching structure, which if it became more relaxed in the late 1960s and 1970s,

87. *Mollie Hunter*. 1987. 76.2 × 101.5 cm (30 × 40 in). Scottish National Portrait Gallery, Edinburgh

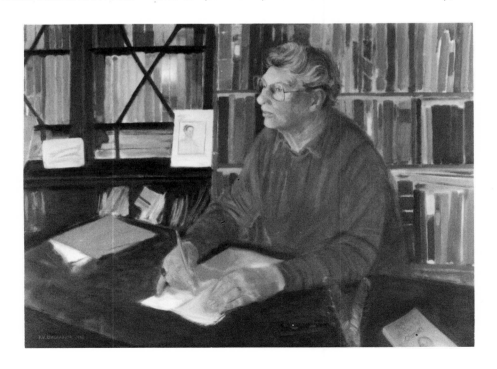

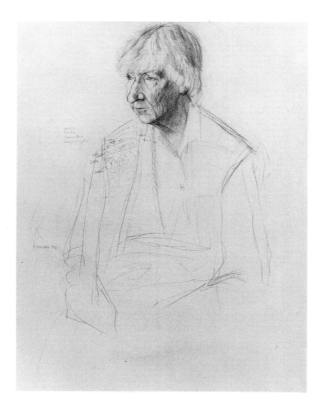

88. *Naomi Mitchison*. 1987. Pencil, 73.8 × 56 cm (29 × 22 in). Collection of the artist

nevertheless maintained its academic framework. Yet she never imposed her ideas, preferring to draw out the students' own personalities. They remember her as a gentle guide whose encouragement was always individual and pertinent to them. For such an unassuming teacher, her influence in attracting a following among painters of flowers and still lifes is notable.

Since 1986 she has continued to be active on behalf of the Royal Scottish Academy, but has been able to concentrate more fully on her own painting and to take on a greater variety of work. A commission to design a window for the new extension to the National Library of Scotland, a poster design for Henley Festival, a lithograph for the Royal Scottish Academy, ceramic designs for the Royal Academy in London are some of the public projects for which she is ever more in demand, quite apart from her many commitments to prepare or contribute to exhibitions and festivals around the country. The ready use of her paintings on postcards and greetings cards bears further witness to her widespread popularity.

Her new-found freedom has also allowed her more time to reflect and experiment with her own work, to develop her ideas in still lifes and in printmaking, as well as in a field she has only recently begun to explore again: portraiture.

Whether she is painting the human figure, landscape, still-life objects or flowers, Elizabeth Blackadder's special achievement lies in her capacity to organize and realize deeply felt experiences. If her painting has been compared, in this respect, to music, it is an intimate form of chamber music that best describes its effect, but chamber music played on ancient as well as modern instruments, or even on Japanese bamboo flutes. Its twentieth-century melody is sometimes melancholy and disturbing, but more frequently it celebrates an experience of post-war Britain that exudes a sense of increasing luxury and well-being.

89. *Still Life, Hiiragiya*. 1986. Watercolour, 64.2 × 94.5 cm (25¼ × 37¼ in). Private collection

90. *Still Life, Nikko*. 1987. Watercolour, 95.3 × 129.5 cm (37½ × 51 in). Gillian Raffles, London

# CHRONOLOGY

Exhibitions are listed at the end of each entry.
• Denotes one-man exhibition.

**1931**    Elizabeth Blackadder born 24 September in Falkirk, Scotland.

**1941**    Father died in June.

**1943–9**    Secondary education at Falkirk High School.

**1949–54**    M.A. Honours Fine Art Degree at Edinburgh College of Art and University of Edinburgh.

**1954**    Awarded Carnegie Travelling Scholarship, Royal Scottish Academy. Visited Yugoslavia, Greece and Italy.

**1954–5**    Awarded Andrew Grant Postgraduate Scholarship.

**1955**    • 'Italian Watercolours and Drawings', Edinburgh College of Art
'Young Contemporaries 1955', R.B.A. Galleries, London
'Eight Young Contemporaries', Gimpel Fils Gallery, London

**1955–6**    Awarded Travelling Scholarship, Edinburgh College of Art. Spent nine months in Italy.

**1956**    Married painter John Houston. Began part-time teaching at Edinburgh College of Art.

**1957**    Commissioned by Arts Council, Scottish Committee, to make lithographs.

**1958**    Travelled to Barcelona and Madrid.

91. John Houston and Elizabeth Blackadder (1954)

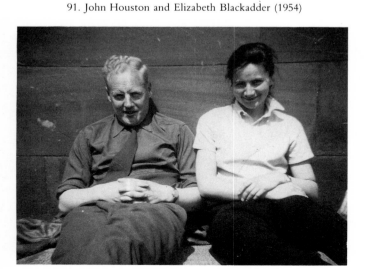

'Original Signed Lithographs', Arts Council Gallery, Edinburgh

**1958–9**    Took teacher-training course and taught art at St Thomas of Aquin's School, Edinburgh.

**1959**    • 57 Gallery, Edinburgh

**1959–61**    Appointed as Librarian, Fine Art Department, University of Edinburgh.

**1960–1**    Produced series of lithographs of Hadrian's Wall for St George's Gallery, London.

**1961**    Museum of Modern Art, New York, commissioned a lithograph, *Dark Hill, Fife*. Travelled to Normandy and Brittany.
• The Scottish Gallery, Edinburgh

**1962**    *White Still Life, Easter* won Guthrie Award. (R.S.A.). Returned to teaching at Edinburgh College of Art (until 1986). The G.P.O. commissioned a lithograph of Staithes, Yorkshire, for use as a poster. Travelled to Greece, visiting many Byzantine churches and pre-Hellenic sites, and to Istanbul to see mosaics.

**1963**    Elected Associate of the Royal Scottish Academy. Moved to Queen's Crescent, Newington. Visited the Loire Valley, Autun and Vezelay.
'20th Century Scottish Painting', Abbot Hall Art Gallery, Kendal

**1963–4**    '14 Scottish Painters', Arts Council Scottish Committee exhibition, London and Glasgow

**1964**    First visit to the South of France.

**1965**    Returned to the South of France.
• Mercury Gallery, London

**1966**    Visited Portugal.
• The Scottish Gallery, Edinburgh
• Thames Gallery, Eton

**1967**    Mrs John Noble and Scottish National Gallery of Modern Art commissioned a tapestry (untitled) for the gallery's permanent collection. Returned to Portugal and Spain, painting in Ciudad Rodrigo, Avila, Nazaré and Ericeira.
• Mercury Gallery, London
• Reading Museum and Art Gallery

**1968**    Visited Holland and Germany.
• Lane Gallery, Bradford
'Three Centuries of Scottish Painting', National Gallery of Canada, Ottawa

92. John Houston: *Portrait of Elizabeth*. 1974. Oil on canvas, 152 × 102 cm (60 × 40 in). Collection of the artist

**1969** Visited the United States, spending several weeks painting in Racine, Wisconsin.
• Mercury Gallery, London
**1969–70** 'Scottish Painting from the Collection of Dr R.A. Lillie, O.B.E.', Scottish Arts Council travelling exhibition
**1970** • Vaccarino Gallery, Florence
**1971** Elected Associate of Royal Academy, London. First visit to Switzerland, painting at Lake Thun.
• Mercury Gallery, London
• Loomshop Gallery, Lower Largo, Fife
'The Edinburgh Art School, 1949–71', Edinburgh College of Art
**1972** Elected Academician of Royal Scottish Academy. Visited Switzerland, then Austria and southern Germany to look at Baroque churches.
**1973** To Switzerland, painting at Schwyz and Lake Lucerne.
• Mercury Gallery, London
**1974** First visit to Isle of Harris.
The Scottish Gallery, Edinburgh Festival exhibition

**1975** • Loomshop Gallery, Lower Largo, Fife
Moved to another house in the south of Edinburgh.
'Edinburgh Ten 30', Scottish Arts Council exhibition, Royal Cambrian Academy of Art, Conway
**1976** Elected Academician of Royal Academy.
• Mercury Gallery, London
• Loomshop Gallery, Lower Largo, Fife
'The Royal Scottish Academy 1826–1976', 150th anniversary exhibition
**1977** Visited Vienna to see the work of Breughel, Schiele and Klimt.
• Middlesborough Art Gallery
• Stirling Gallery
'British Painting, 1952–1977', Royal Academy, London
'The Stirling Gallery 1st Exhibition Drawings'
**1978** Began sketchbooks and series of paintings of flowers from her own garden. Series of drawings and watercolours of Normandy and Brittany coastline.
• Mercury Gallery, London
• Yehudi Menuhin School, Surrey
'Painters in Parallel', Scottish Arts Council, Edinburgh Festival exhibition, Edinburgh College of Art
**1979** Mercury Gallery, London, commissioned two lithographs, *Still Life with Indian Toy* and *Black Cat*. Painted in Normandy and Brittany.
'Scottish Paintings and Tapestries', Offenburg, Germany
'The Plant', Scottish Arts Council exhibition, Edinburgh

93. Elizabeth at work in her garden

**1980** Edinburgh Tapestry Company commissioned a tapestry, *Eastern Still Life*. Painted in Normandy and Brittany.
• Mercury Gallery, London
'The British Art Show', Arts Council exhibition, Sheffield, Bristol and Newcastle
'Master Weavers—Tapestry from the Dovecot Studios 1912–1980', Scottish Arts Council, Edinburgh Festival exhibition

**1981–2** • 'Elizabeth Blackadder', Scottish Arts Council retrospective exhibition, Edinburgh, Sheffield, Aberdeen, Liverpool and Cardiff
• Bohun Gallery, Henley-on-Thames
• Theo Waddington Gallery, Toronto
• Mercury Gallery, London

**1982** Visited Toronto and New York.
'Six Scottish Painters', Graham Gallery, New York
'A Mansion of Many Chambers—"Beauty" and Other Works', Arts Council Collection exhibition

**1983** Visited New York and the South of France. Received Pimm's Award for a Work on Paper, Royal Academy Summer Exhibition.
• (exhibition with sculptures by Henry Moore) Lillian Heidenberg Gallery, New York
New Scottish Prints, City Gallery, New York

**1984** Reckitt and Colman commissioned a tapestry. A print, *Still Life with Wooden Toys*, commissioned by Mercury Gallery, London. Visited Berlin. Mother died in September.
• Mercury Gallery, London

**1985** First visit to Japan. Began etching at Glasgow Print Studio.
'Portraits on Paper', Scottish Arts Council travelling exhibition
'Still Life', Harris Museum and Art Gallery, Preston
'Unique and Original', Glasgow Print Studio
• Mercury Gallery, Edinburgh Festival exhibition

**1986** Retired from full-time teaching. Second visit to Japan, via Hong Kong.
'Scottish Landscape painting', National Museum of Brazil, Rio de Janeiro
• Lillian Heidenberg Gallery, New York
'20/30', Laing Art Gallery, Newcastle
'The Flower Show', touring exhibition, Stoke-on-Trent, York, Southampton and Durham

**1987** Lithograph of *Lilies*. Painted portraits of Mollie Hunter (commissioned by Scottish National Portrait Gallery), and Naomi

Mitchison. Stained-glass window commissioned by National Library of Scotland. Tapestries commissioned by Edinburgh Tapestry Company.
• Mercury Gallery, Henley Festival exhibition
• Salisbury Playhouse Gallery
'West of England Academy, Members Exhibition', Bristol
'Elizabeth Blackadder and John Houston', Glasgow Print Studio Gallery
'The Botanical Scene', Broughton Gallery, Broughton, Peebles
'Art into Botany', Talbot Rice Gallery, Edinburgh

**1988** Joint winner of the Watercolour Foundation Award, Royal Academy Summer Exhibition.
'Oriel 31, The Scottish Show', touring exhibition in Wales
'Flowers of Scotland: Paintings by Five Contemporary Scottish Artists', Fine Art Society, Glasgow
• Mercury Gallery, London

94. Elizabeth Blackadder in the studio

# SELECT BIBLIOGRAPHY

EMILIO COIA, 'Elizabeth Blackadder A.R.A.', *Scottish Field*, November 1966, pp. 60–1

T. ELDER DICKSON, 'Scottish Painting: the Modern Spirit', *Studio International*, December 1963, pp. 236–43

'Elizabeth Blackadder, Still Life: Objects and Flowers', in *Henley Festival of Music and the Arts*, souvenir programme, 1987, pp. 9–12

DOUGLAS HALL, 'Elizabeth Blackadder', *The Scottish Art Review*, Vol. IX, No. 4, 1964, pp. 9–12 and 31

WILLIAM PACKER, *Elizabeth Blackadder*, Mercury Gallery, London and Edinburgh, 1985

PHILIP VANN, 'R.A. Travel: Eastern Eden. Elizabeth Blackadder R.A. tells Philip Vann of her Japanese inspirations', *R.A. Magazine*, 15, 1987, pp. 46–8

## Catalogues

WILLIAM PACKER (foreword by Carel Weight), *Elizabeth Blackadder*, Scottish Arts Council exhibition, Edinburgh, 1981

WILLIAM PACKER, *Elizabeth Blackadder and John Houston*, Glasgow Print Studio Gallery, 1987

## Writings by the artist

With Dr Brinsley Burbidge, introduction to the catalogue of *The Plant: Images of plants, from the scientifically accurate to the purely imaginative, selected from artists working since the war and closely connected with Scotland*, Scottish Arts Council, Edinburgh, 1987

Statement in Charlotte Parry-Crooke (ed.), *Contemporary British Artists with Photographs by Walia*, London, 1979

## Broadcast material

*Conversations with Artists: Elizabeth Blackadder*. Interview with Edward Lucie-Smith, BBC Radio 3, 18 October 1982. Produced by Judith Bumpus

*A Feeling for Paint: Four Artists and their Materials* (Elizabeth Blackadder, David Tindle, Robin Philipson and Bert Irvin), BBC 2, 4 April 1983. Produced and directed by Anne James

Interview with Roger Billcliffe in *Tuesday Review*, BBC Radio Scotland, 5 May 1987. Produced by Caroline Adam

## Photographic Acknowledgements

The publishers wish to thank all museums, galleries, private collectors and others who have contributed towards the reproductions in this book. Particular thanks are extended to Gillian Raffles of the Mercury Gallery, who has provided many of the photographs. Further acknowledgement is made to the following: 6 Reproduced by permission of the Duke of Devonshire; 21 Collection, The Museum of Modern Art, New York. Gift of the Junior Council; 57 Metropolitan Borough of Sefton Libraries and Arts Department. The Atkinson Art Gallery, Southport; 76 Kirklees Metropolitan Council. Huddersfield Art Gallery; 83 Collection The National Museum of Women in the Arts, Gift of Wallace and Wilhelmina Holladay.

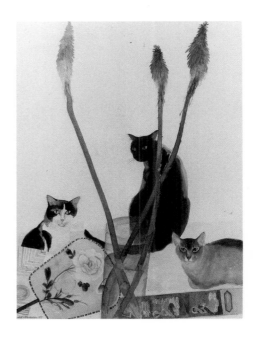

95. (right) *Three Cats and Three Kniphofia*. 1986. Watercolour, 76.2 × 57.8 cm (30 × 22¾ in). Private collection

# INDEX